# body&soul

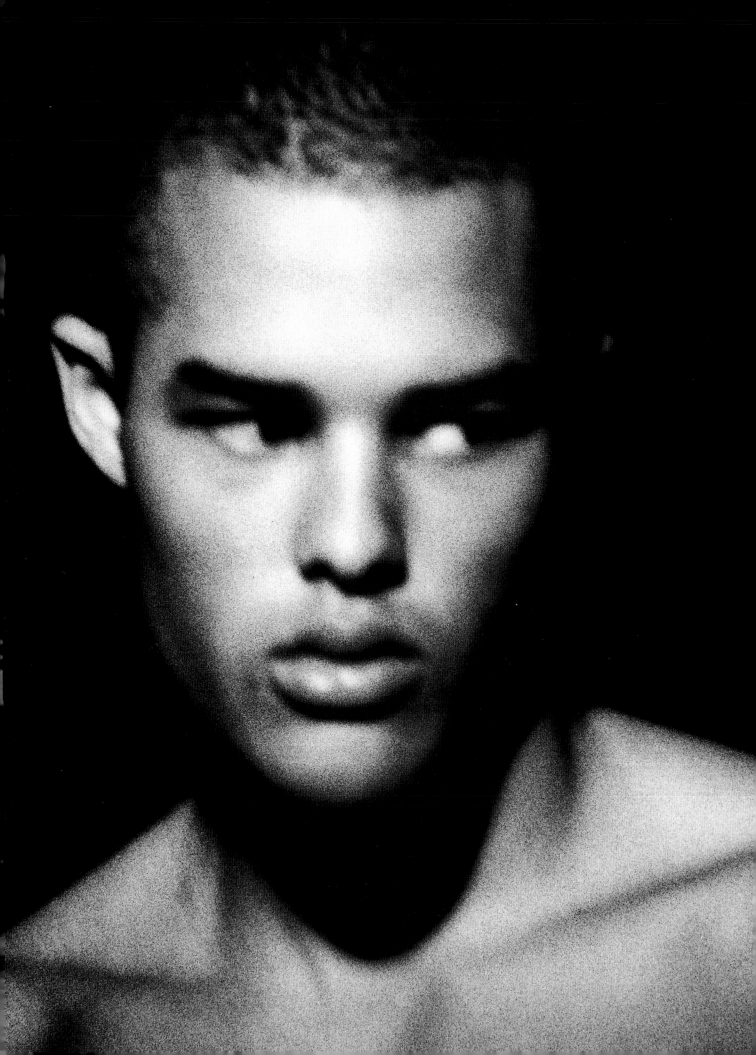

blo Ravazzani
son Olive

# body&soul
## the black
## male book

By Duane Thomas
with an introduction by Veronica Webb

Universe

Bill Wylie
Allan Houston

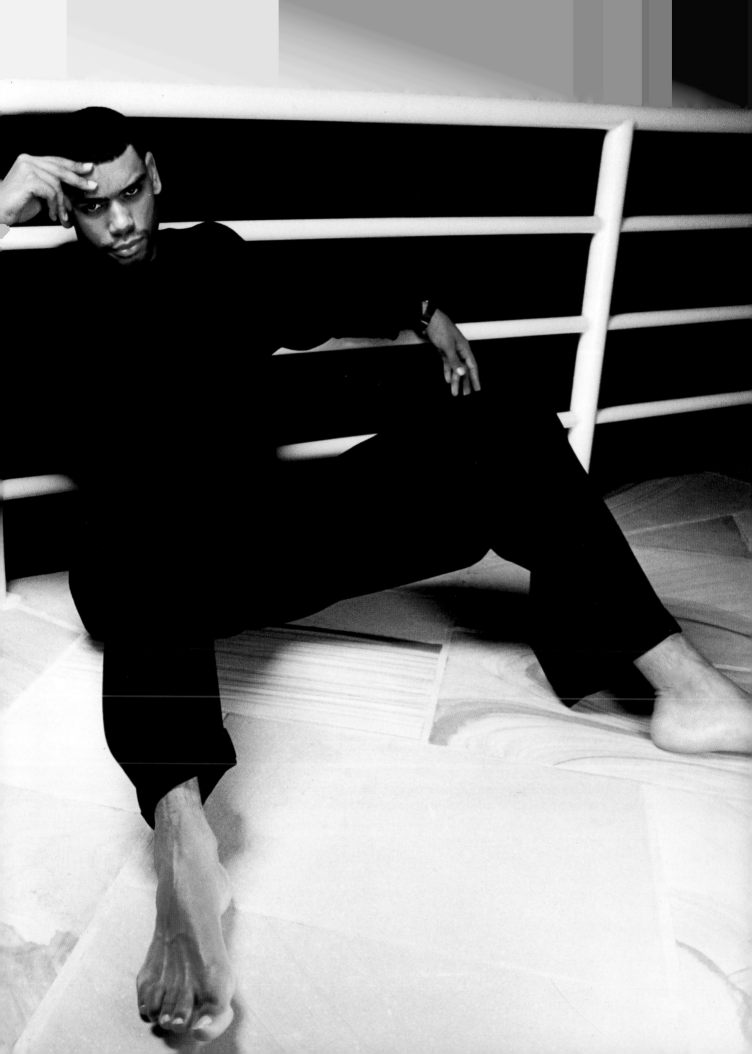

*Body & Soul*
is a celebration
of black men.

We are such
beautiful people.
—Bethann Hardison,
talent manager

This book is dedicated to
my parents, Yvonne and Jerome,
my sisters, Nikki and Daisy,
and my nephew, Bosie.

First published in the United States of America
in 1998 by UNIVERSE PUBLISHING
A Division of Rizzoli International Publications, Inc.
300 Park Avenue South, New York, NY 10010

Copyright © 1998 Duane Thomas
Introduction copyright © 1998 Veronica Webb

Book design by Duane Thomas

99 00 / 10 9 8 7 6 5 4 3

Library of Congress Catalog Card Number:
98-60154

Printed in Italy

Cover:
Philippe McClelland
D'Angelo

Right:
Marc Baptiste
Bryce Wilson

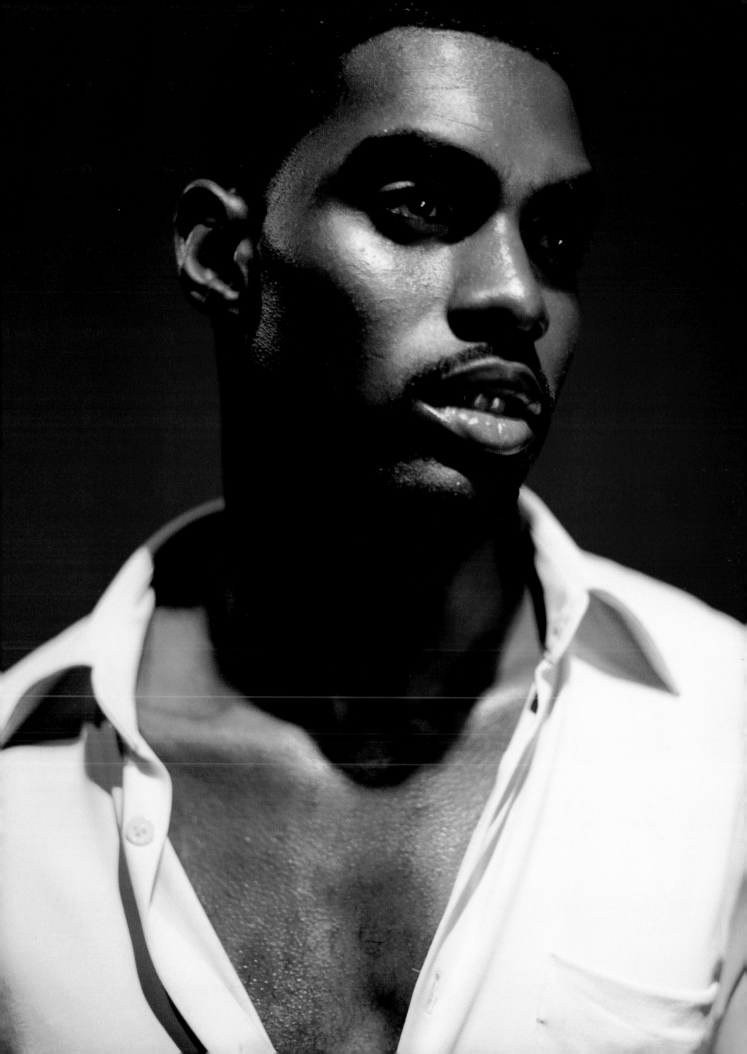

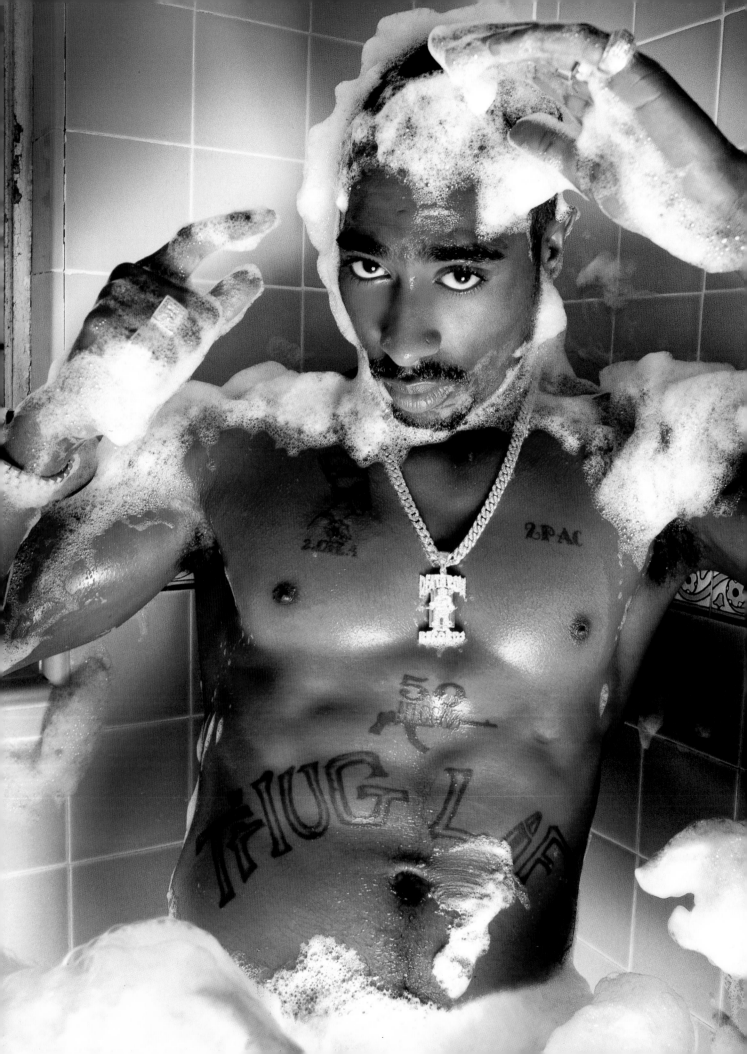

# introduction
## veronica webb

# The power and magic of photography, television and film is in their availability—and their inescapability. And today, black men undeniably share in that power.

Economic or educational elitism has little place in today's image media. And whether you're insulted or enchanted by the barrage of images our popular culture generates, it is almost impossible not to be seduced by them, and indeed, not to be at least partly defined by them. In the early part of this century, the written word was the major influence on public opinion and was the major source of news on the fashions, trends, and lifestyles of the world at large; now, images count for much more than letters in our media-dependent and -influenced culture.

Portrayals of black men in the media are as old as the media itself, rooted in the earliest days of racial ignorance and paranoia when images of the black man amounted to little more than those of servants and pandering entertainers, and later, criminals, deviants, and urban "savages." And while the absurd injustices of this past still linger like a deformity in the mythic DNA of our nation, society and popular culture have undeniably evolved, thanks to the strong voices and unforgettable faces of blacks unafraid to speak out and make themselves seen and understood.

The 1960s was a turning point in the way blacks perceived themselves and how society at large perceived us. James Brown came along and told America to get on the good foot, chanting, "Say it Loud! I'm Black and I'm Proud!" Black Power movements told us to look in the mirror and say, "Black is Beautiful." And later, other musicians picked up on James Brown's legacy of pride, making us affirm the obvious: "We're not bums. We're the *bomb*!" By the 1980s, the media was finally beginning, ever so

slowly, to open up to newer, more real portrayals of blacks.

Today, looking at the variety and vitality of media images of black men and the massive celebrity so many of them enjoy, you could say we've almost come full circle. Their newfound visibility is almost as remarkable as their diversity: from NBA bad boy Dennis Rodman—now a fashion figure so recognizable that Janet Jackson appeared on the cover of *Behind the Velvet Ropes* with dyed hair and piercings à la Rodman—to Tyson Beckford, the first black male supermodel, who has ushered in a whole new type of male beauty, to the similarly endowed Djimon Hounsou, whose quiet dignity carried the movie *Amistad*. And if the stunning photographs featured in this collection prove anything, it is that each brother shown in these pages is first and foremost an individual.

Whether it's Rodman's careless irreverence or Beckford's strength and masculinity, each man pictured in this book has his own style, attitude, and story, a little bit of which is told in each photograph. Each man's story, in turn, plays a small part in the media revolution that black men are helping to create. It's been a long journey from the early days when images of black men were mere tools of oppression, and there's more road to be traveled. Every one of these brothers is by nature and force of history a self-made man, and while the sheer physical beauty of each of them is evident—really evident, in some cases—it is the beauty beneath the skin, the soul and the sense of style, that these photographs best evoke.

David LaChapelle
Tupac Shakur

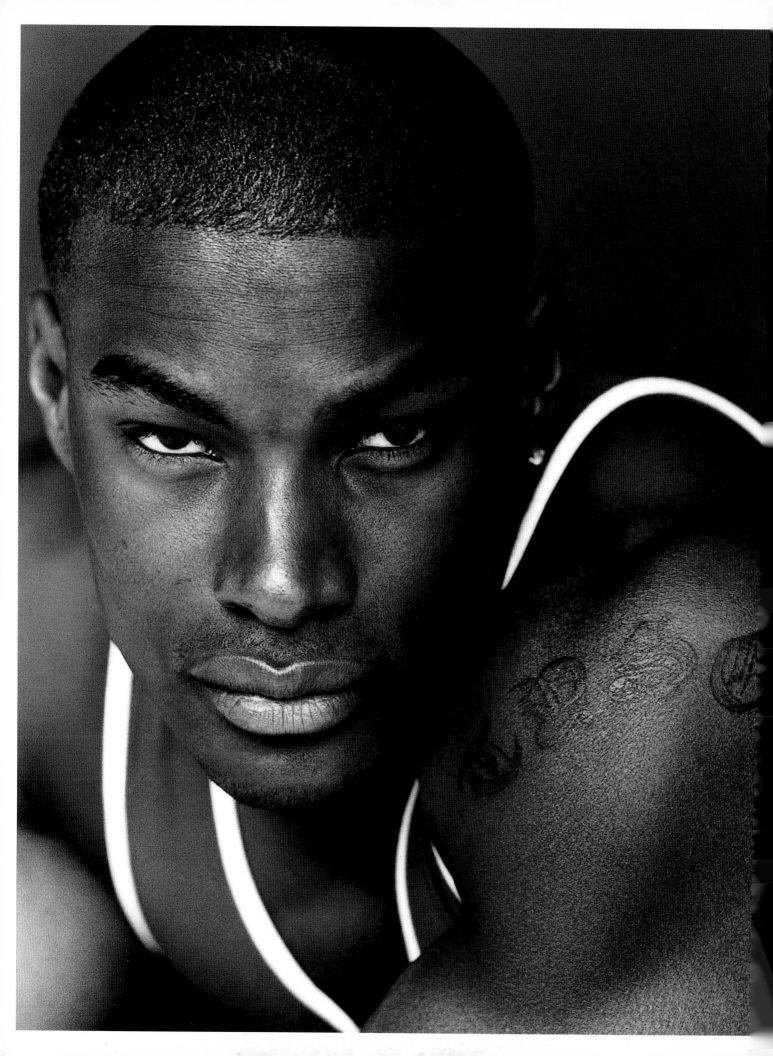

Left:
Bob Frame
Tyson Beckford

Right:
Bob Frame
Jason Olive

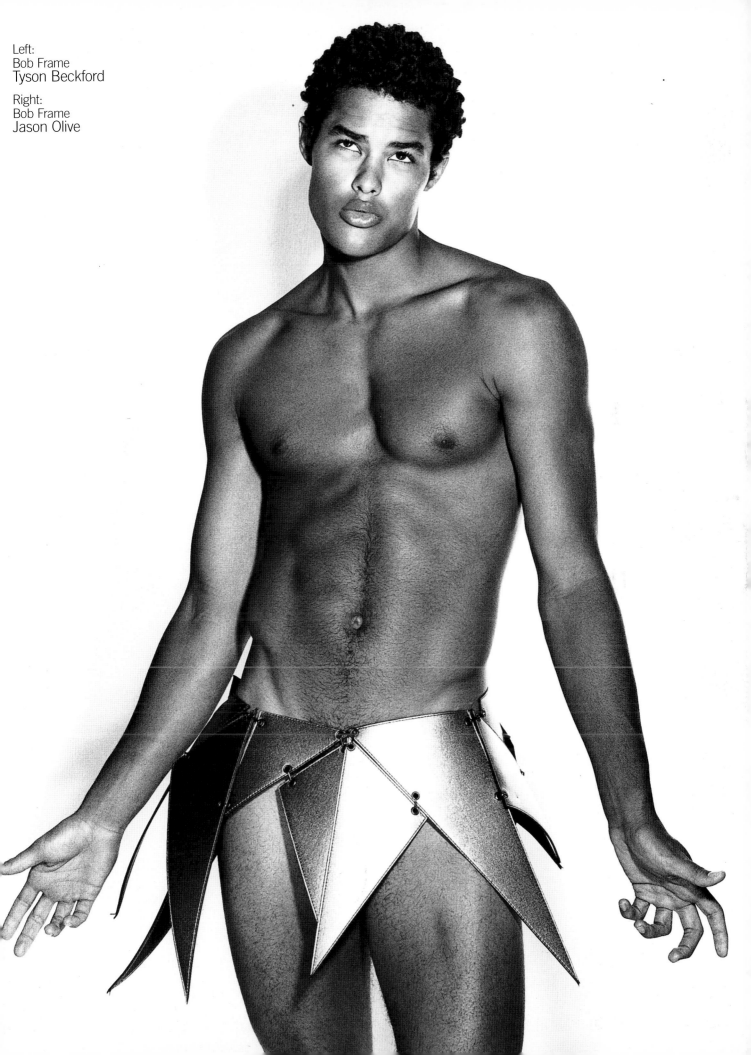

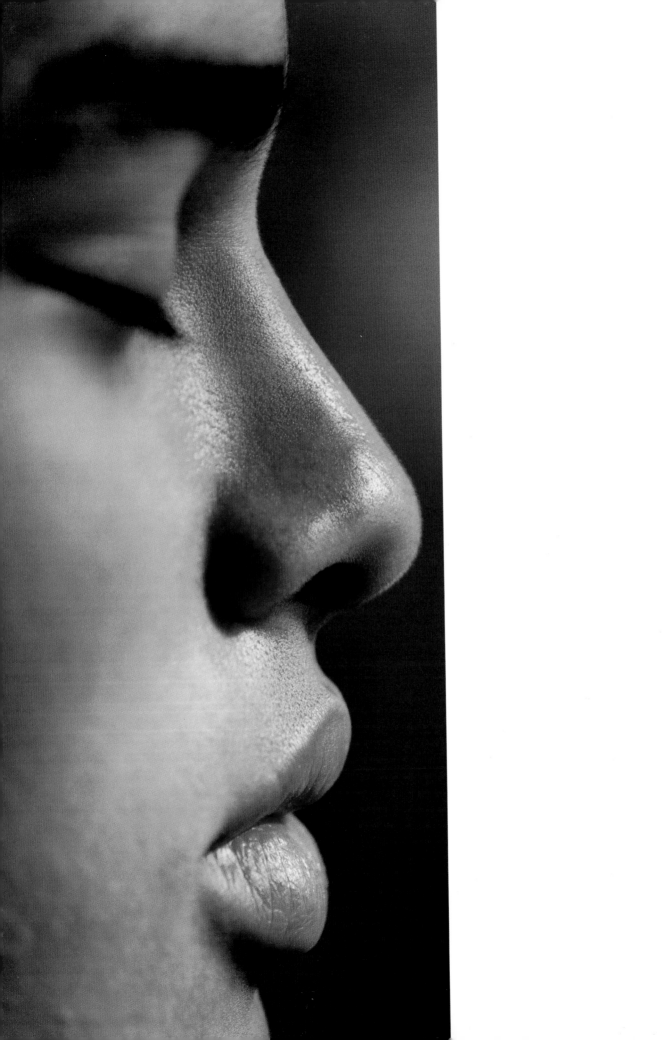

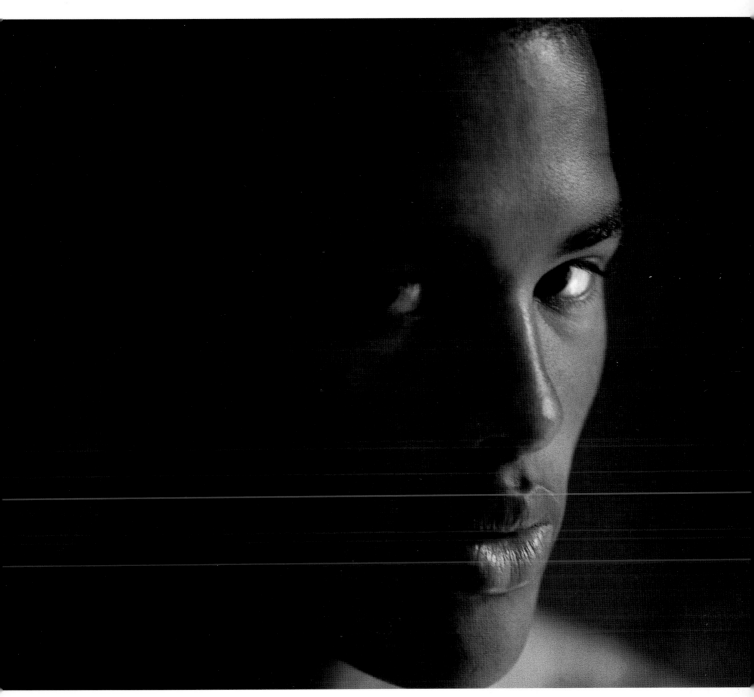

Michael Stratton
Jason Olive

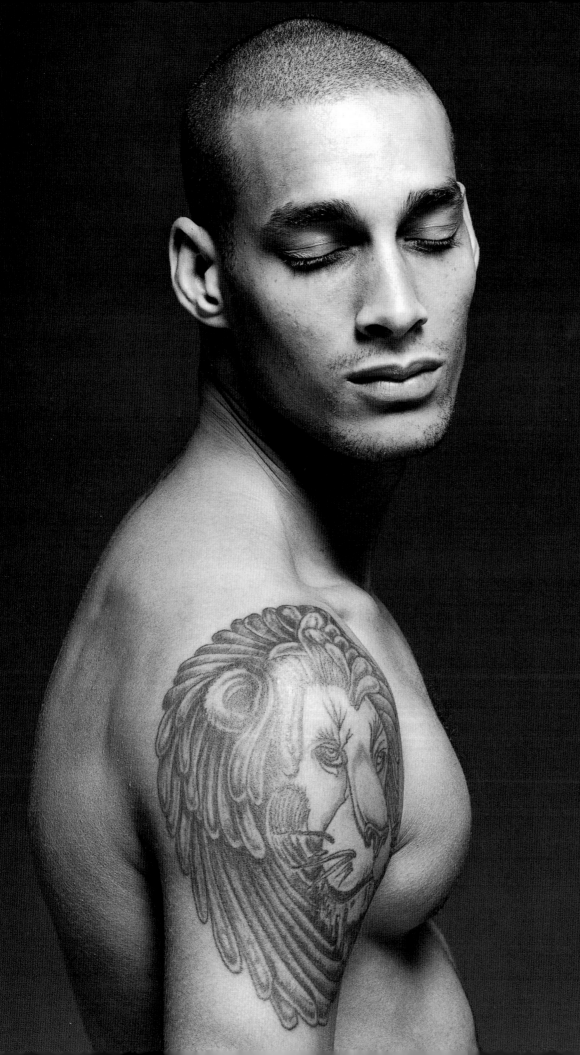

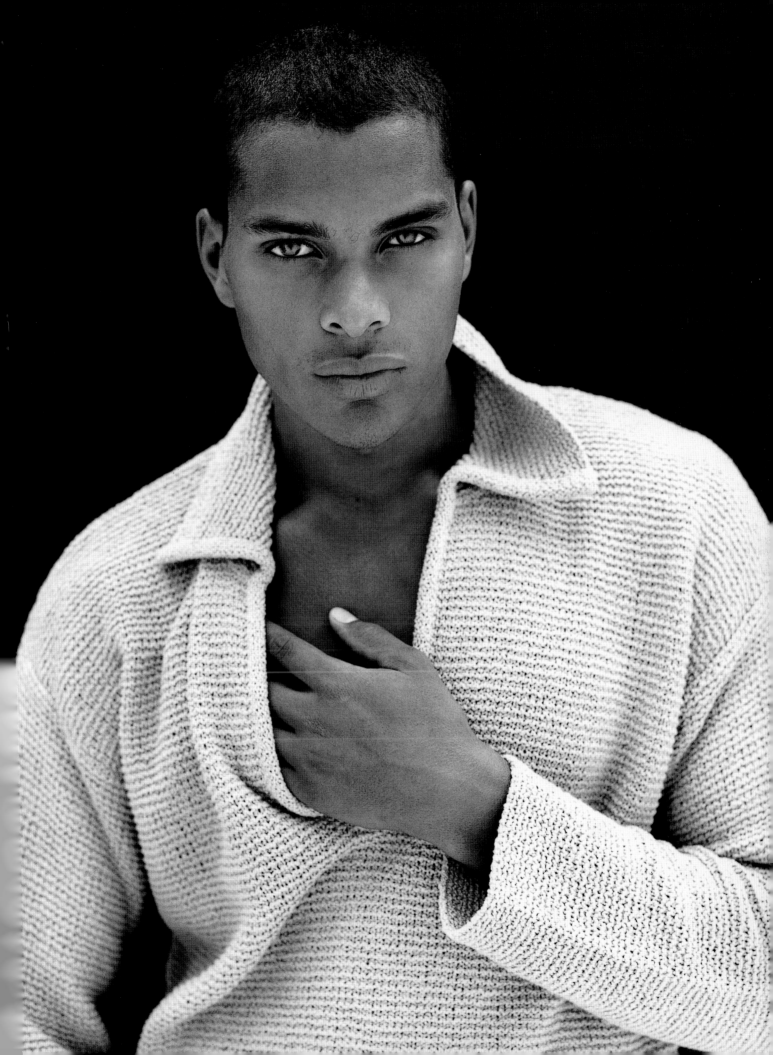

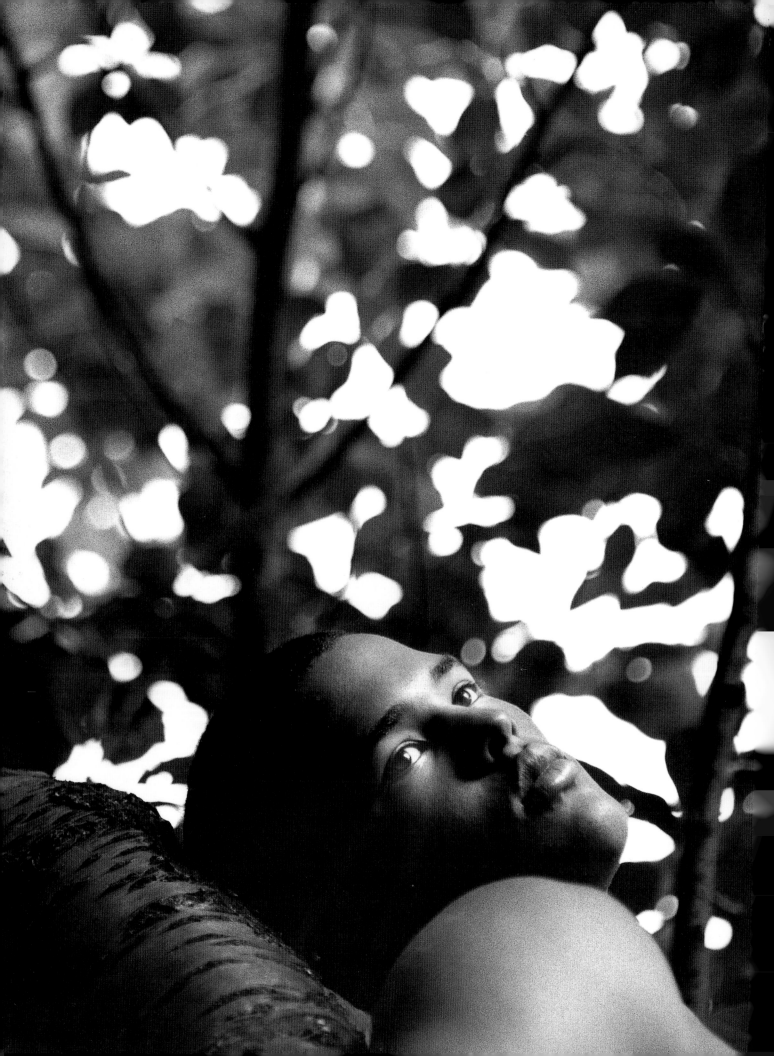

Michael Stratton
Jason Olive

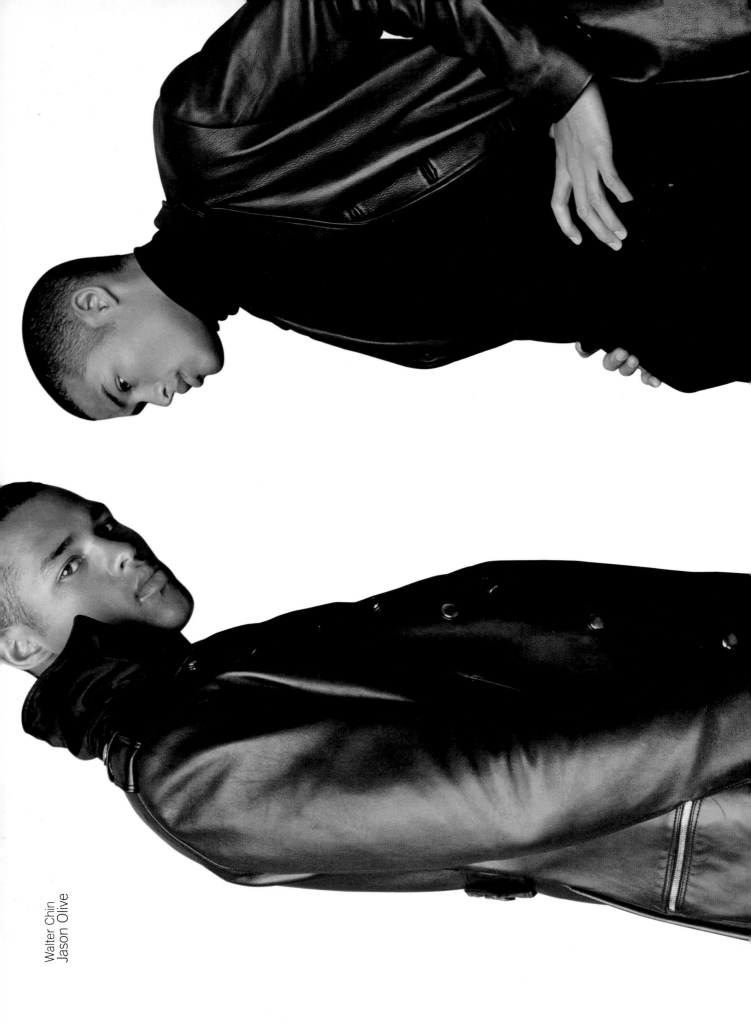

Walter Chin
Jason Olive

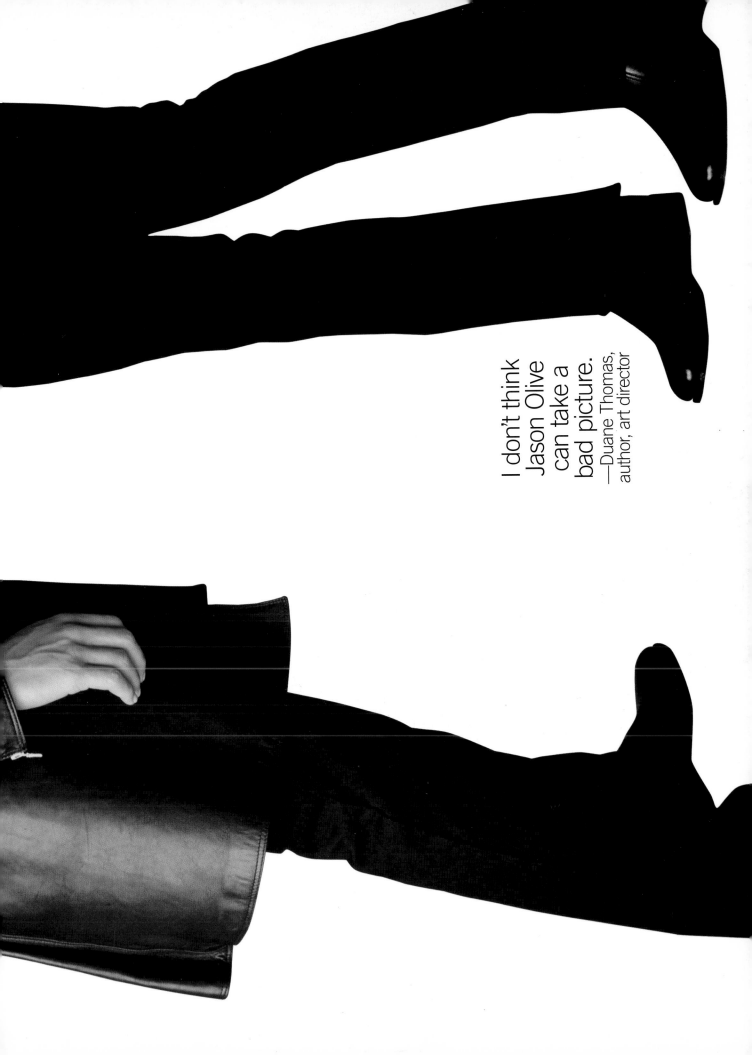

I don't think
Jason Olive
can take a
bad picture.
—Duane Thomas,
author, art director

Marc Baptiste
Tyson Beckford

Tyson impressed
the modeling
industry enough that
it simply could not
deny his good looks.
—Bethann Hardison,
talent manager

Tyson Beckford
is a nineties
phenomenon.
There is no way
you would have
had a brother
that dark, muscular
and masculine in
advertising
ten years ago.
—Nelson George,
author, screenwriter

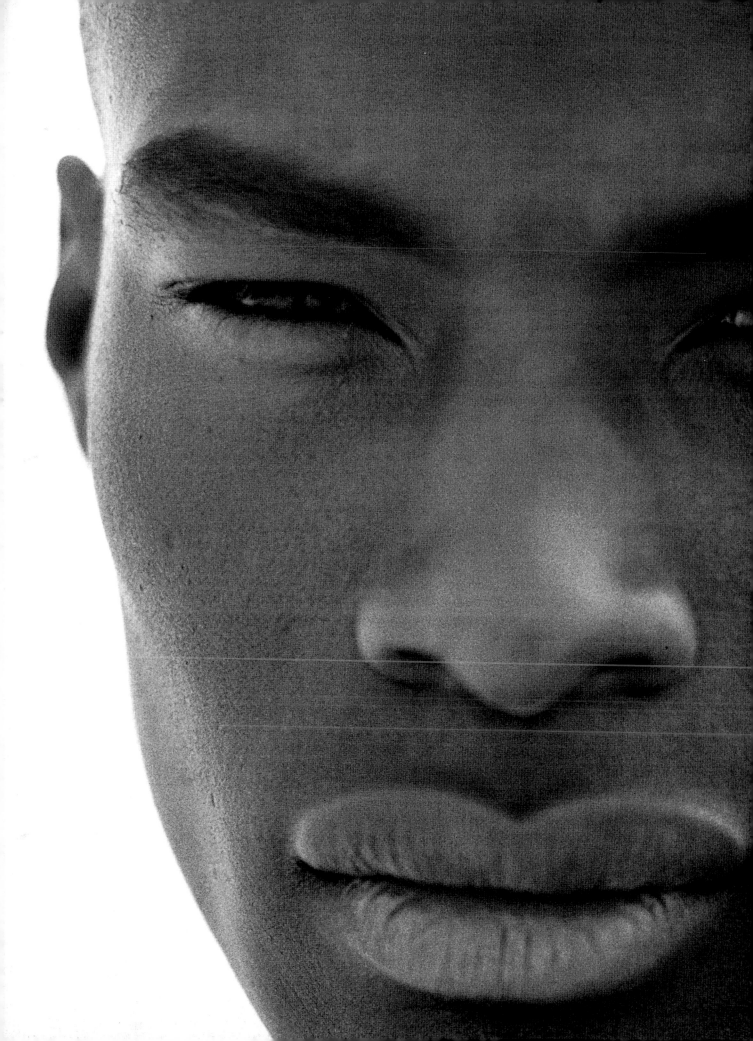

Left:
Marc Baptiste
Tyson Beckford

Right:
Charlie Pizzarello

Tyson is just straight-out fine. He is so fine he hurts you.
—Vivica Fox, actress

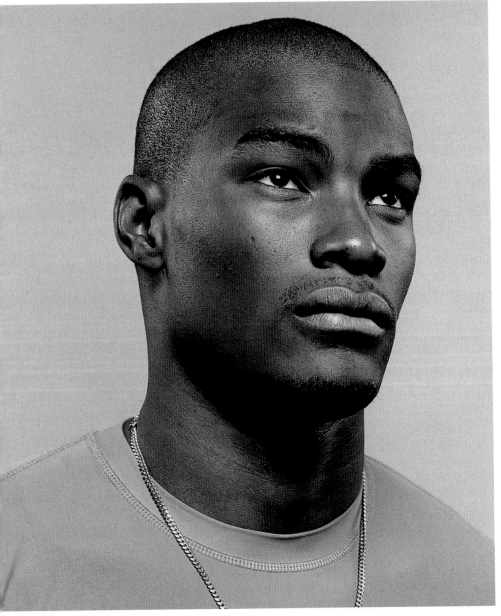

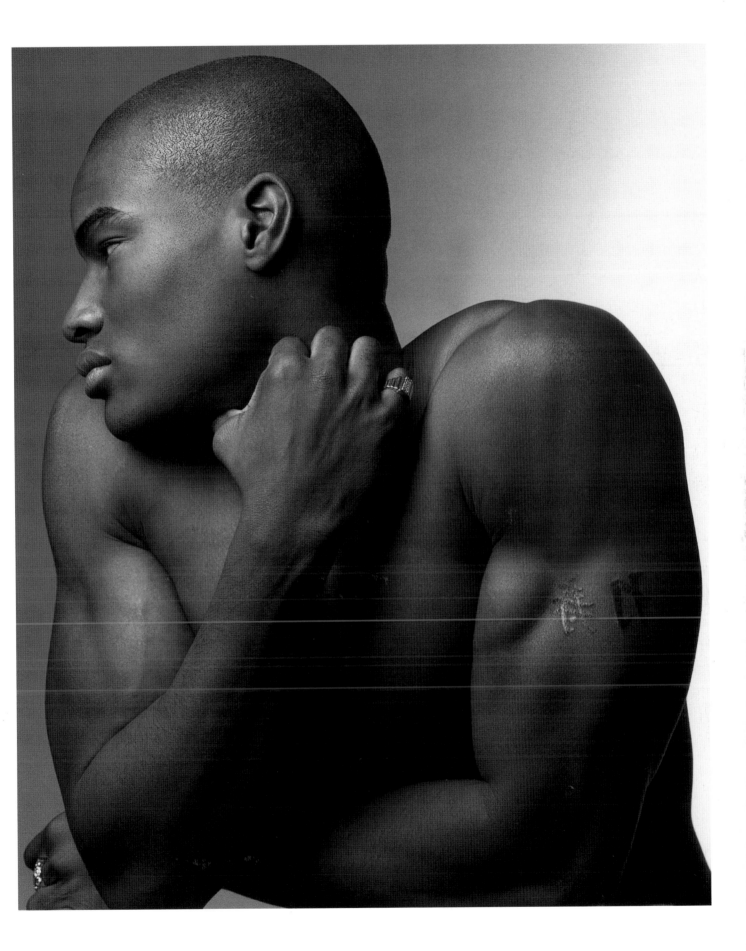

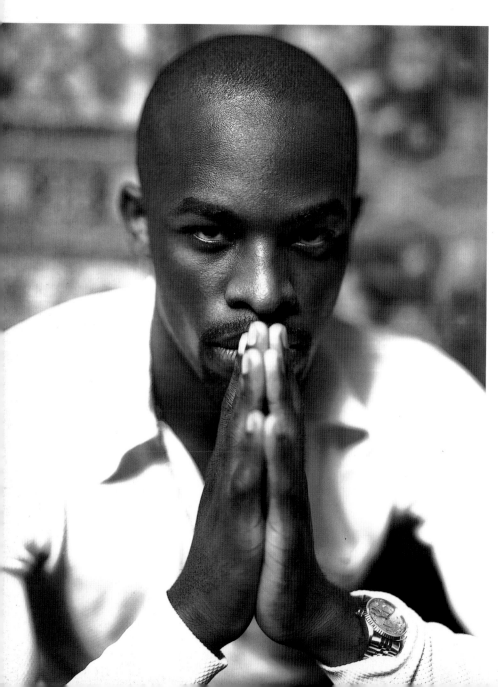

Left:
Jonathan Mannion
Joe

Right:
Michael Stratton
Travis

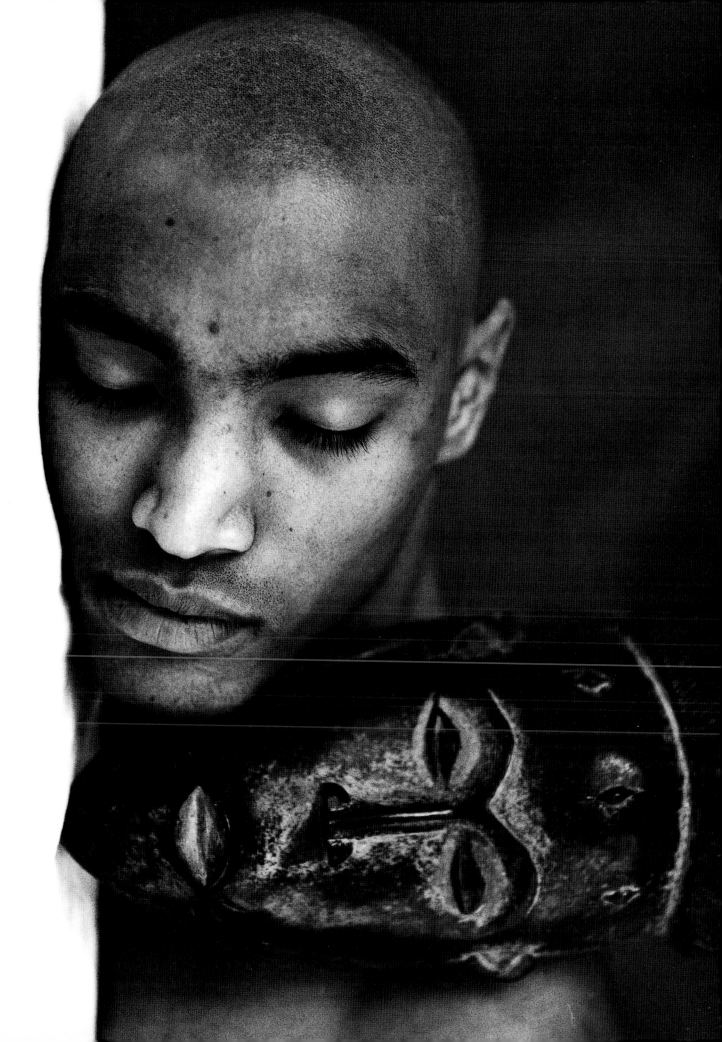

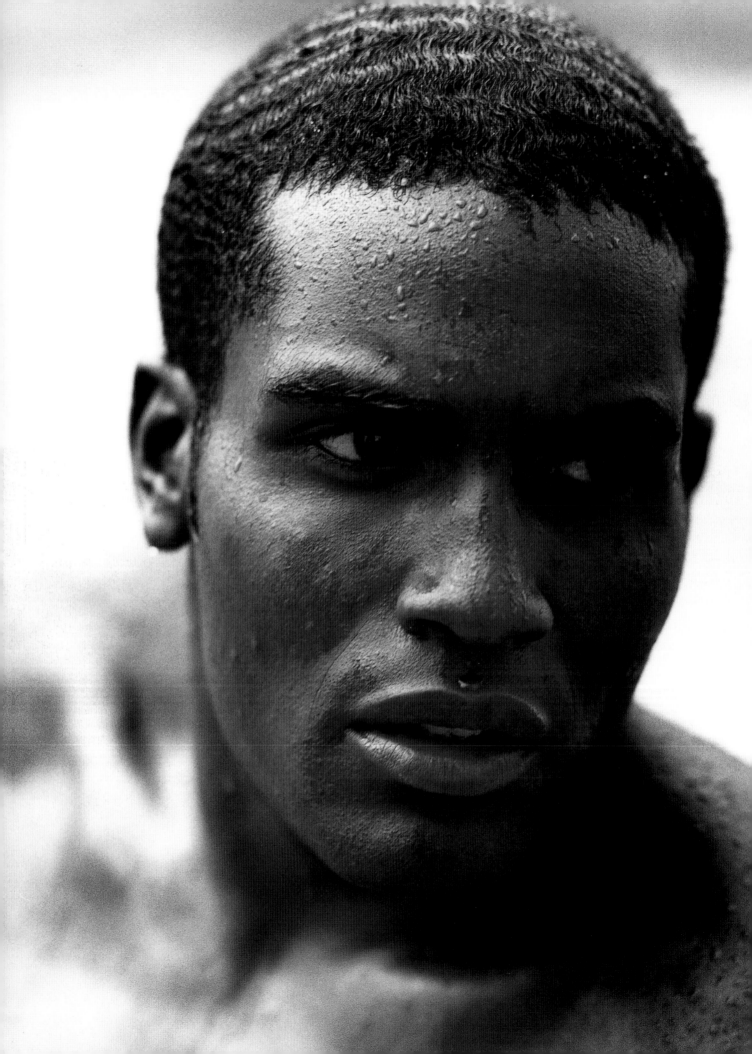

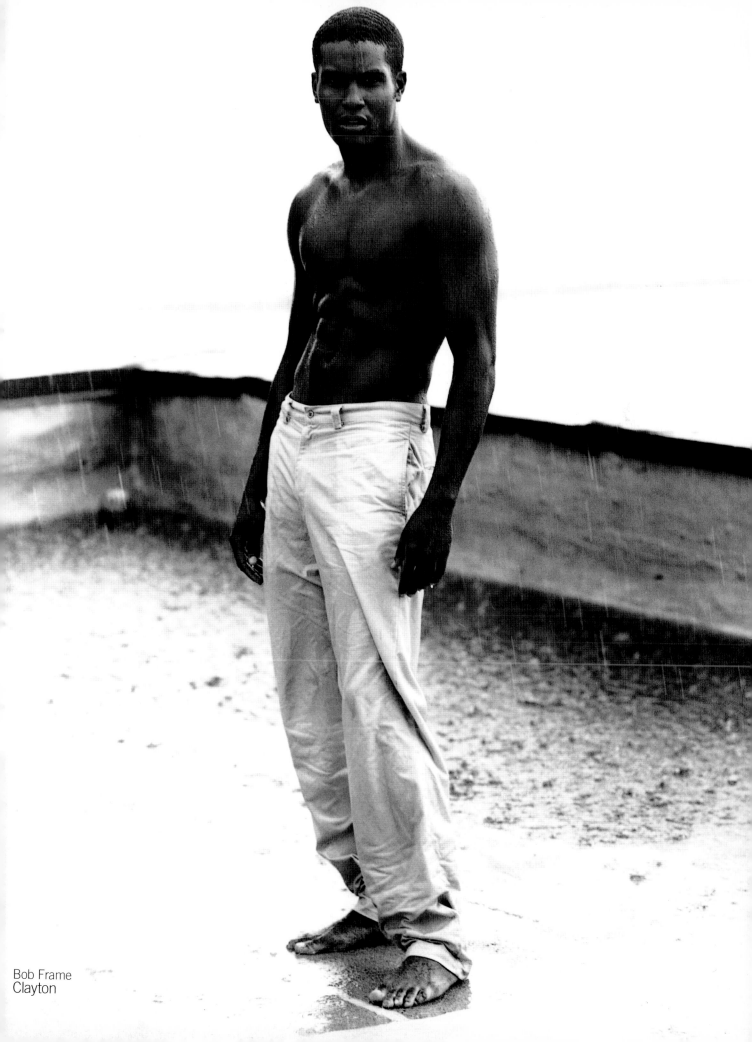

Bob Frame
Clayton

I don't think of masculinity when I think of men. I just see what's beautiful about them.
—Bethann Hardison, talent manager

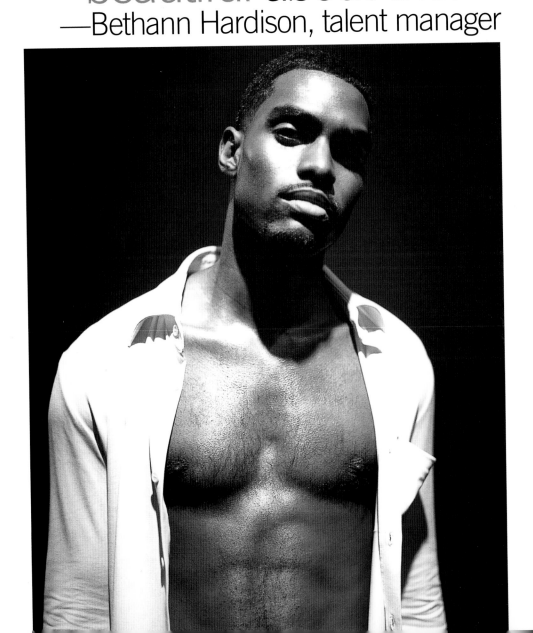

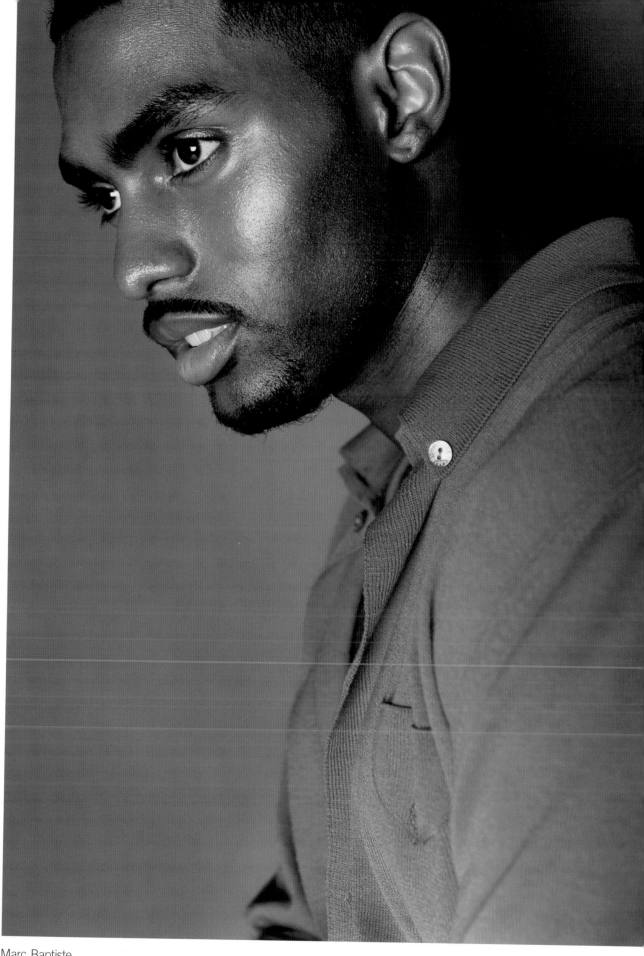

Marc Baptiste
Bryce Wilson

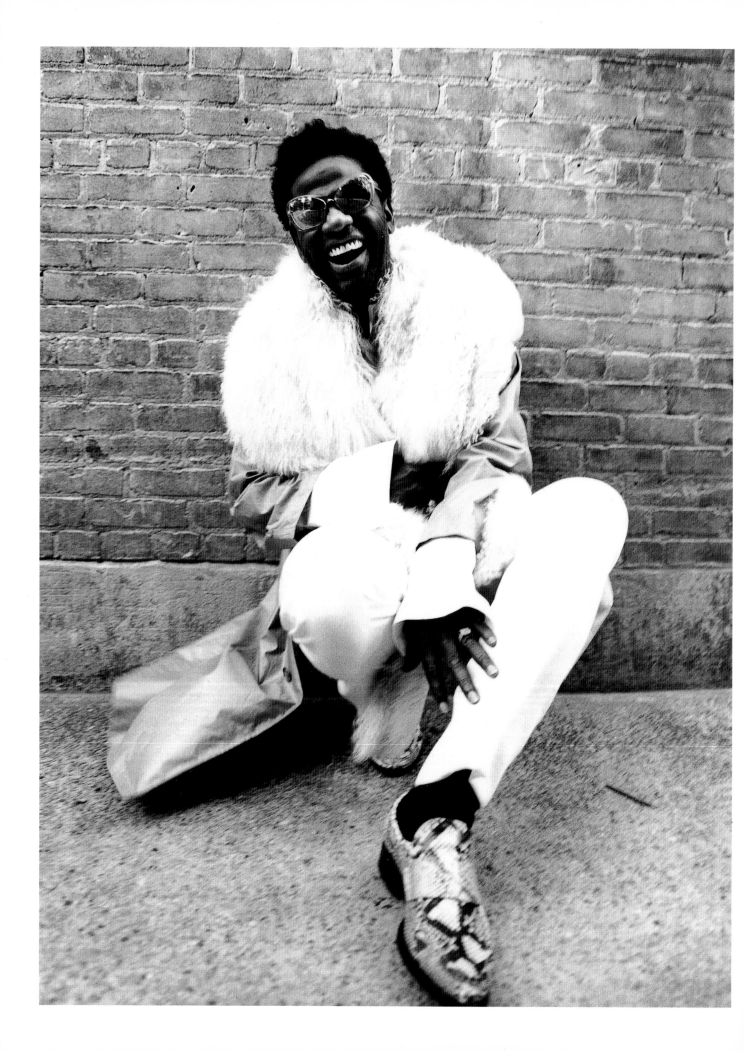

The black man's masculinity is a very powerful image. —Beverly Johnson, supermodel

Eric Johnson
Al Green

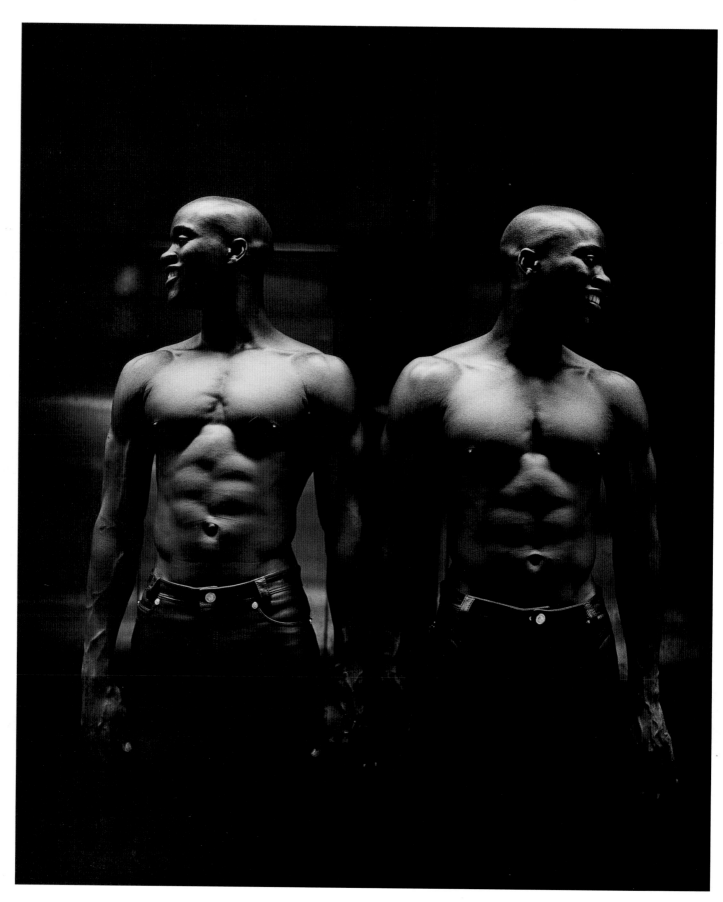

Thierry Le Gouès
Charles, Charleton

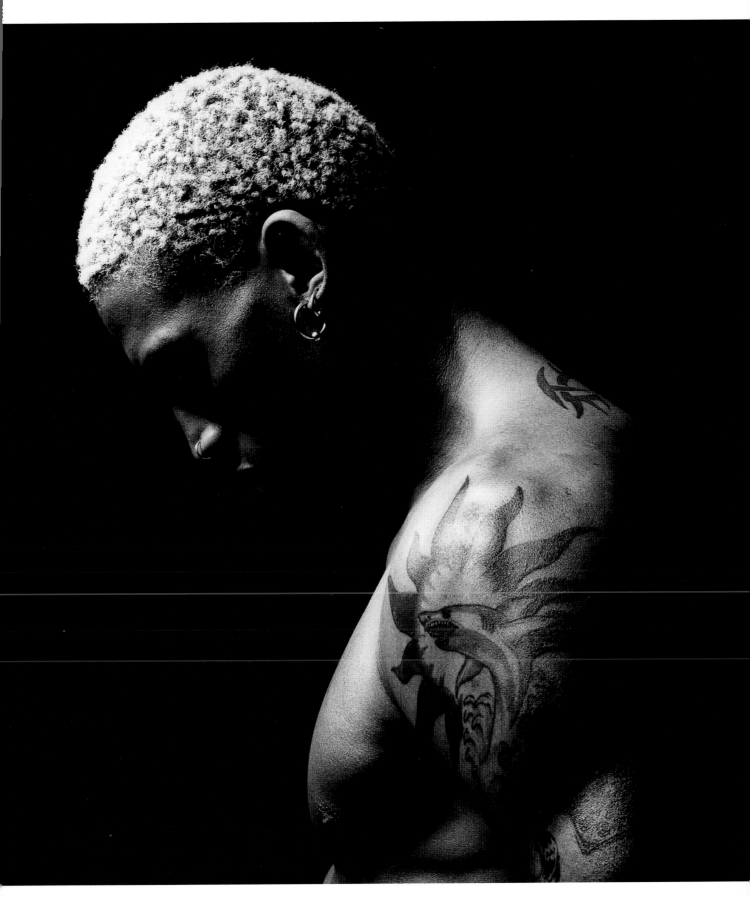

Thierry Le Gouès
Dennis Rodman

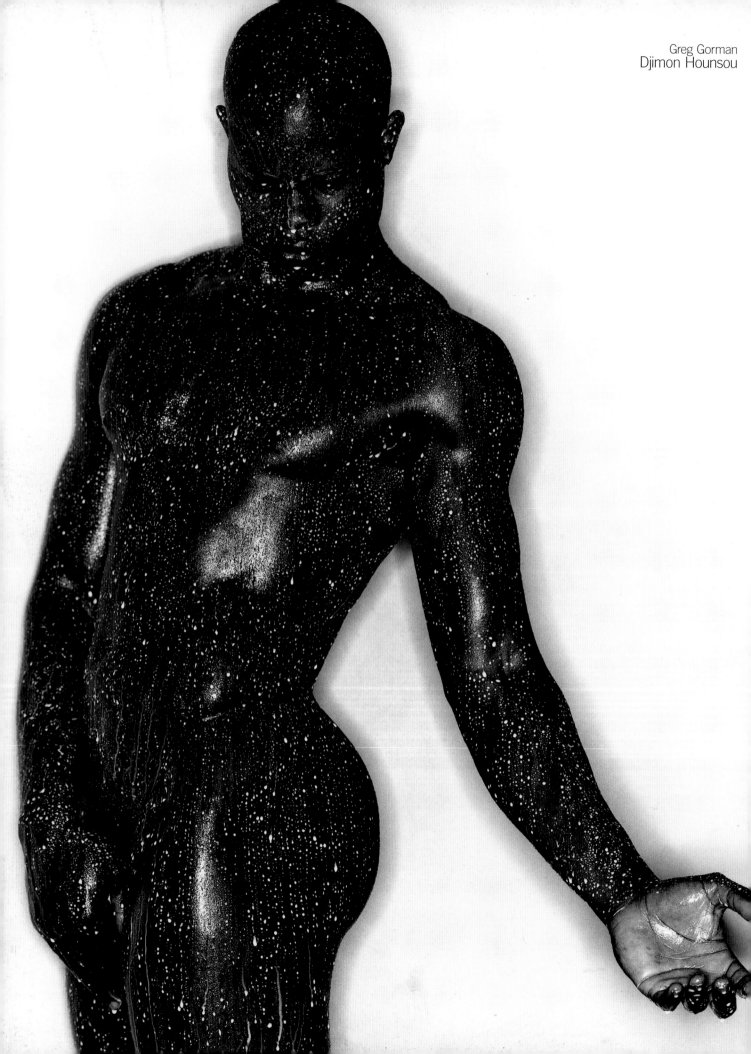

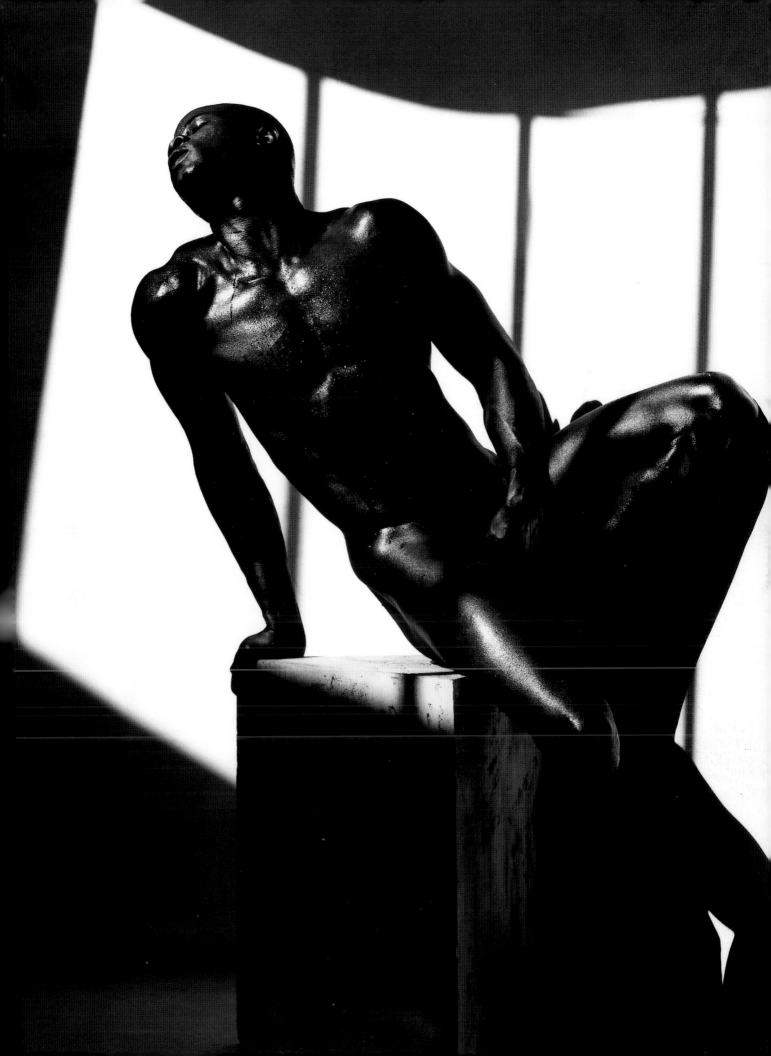

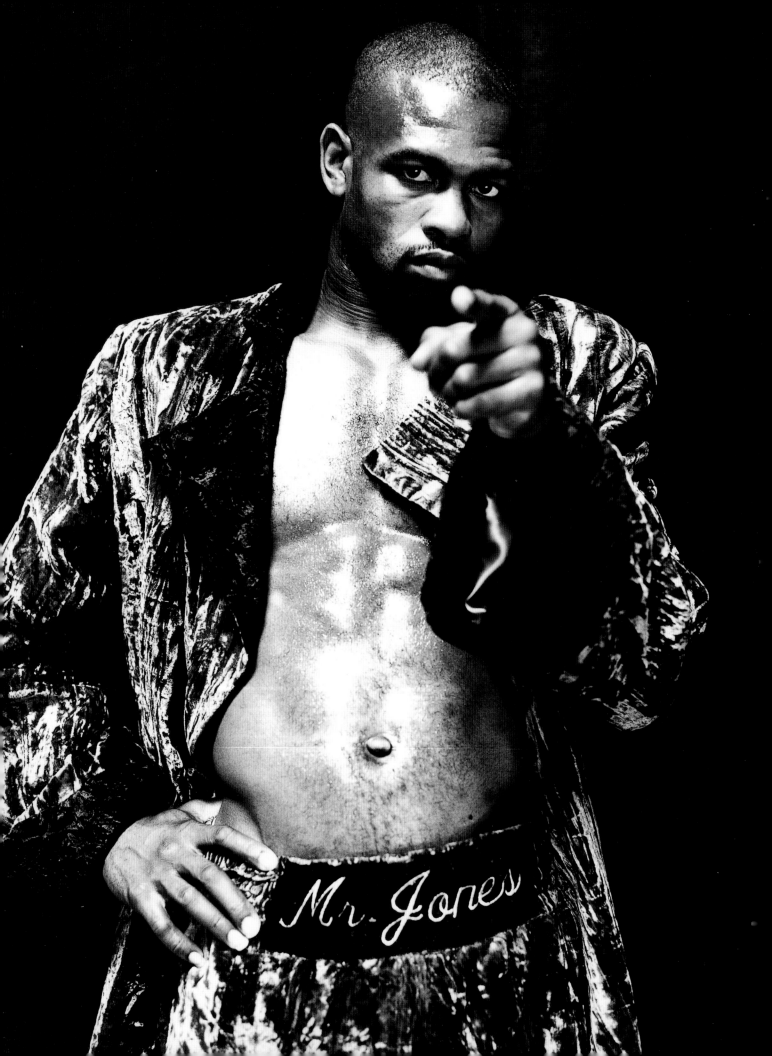

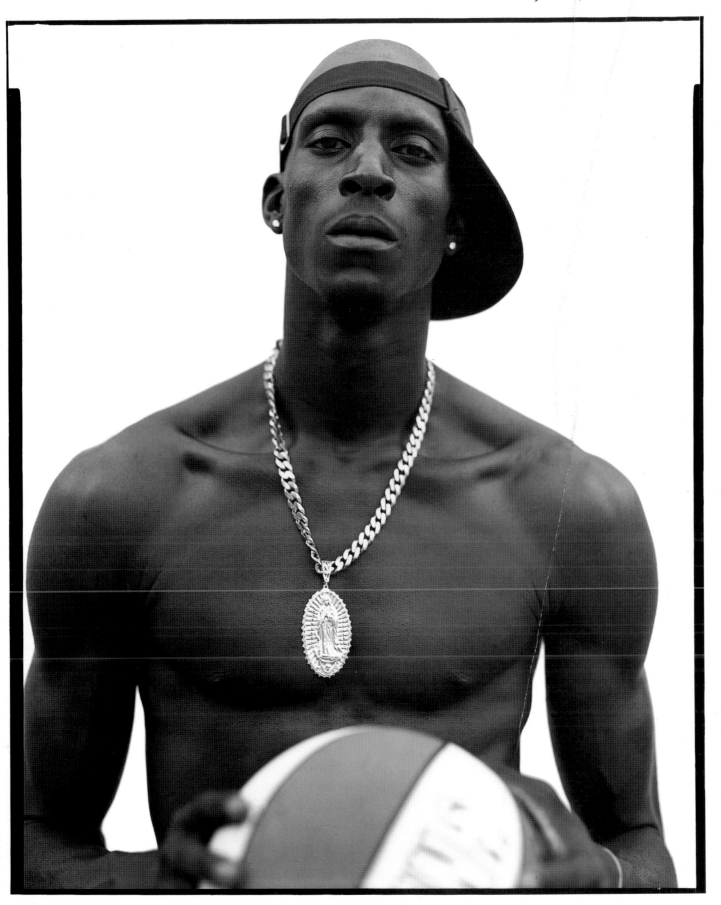

Left:
Jonathan Mannion
Stephon Marbury

Right:
Geoffroy de Boismenu
Jon Secada

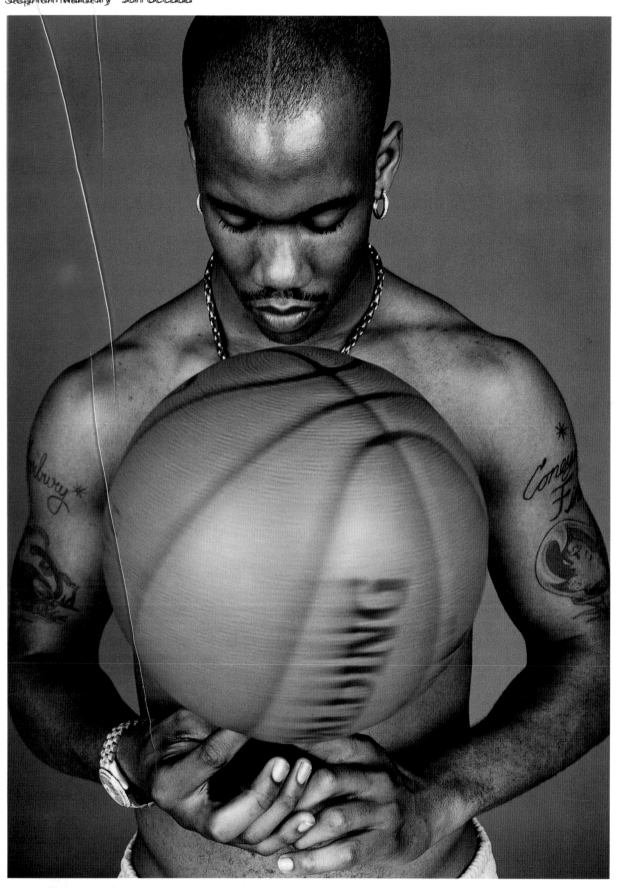

Left:
Jonathan Mannion
Stephon Marbury

Right:
Geoffroy de Boismenu
Jon Secada

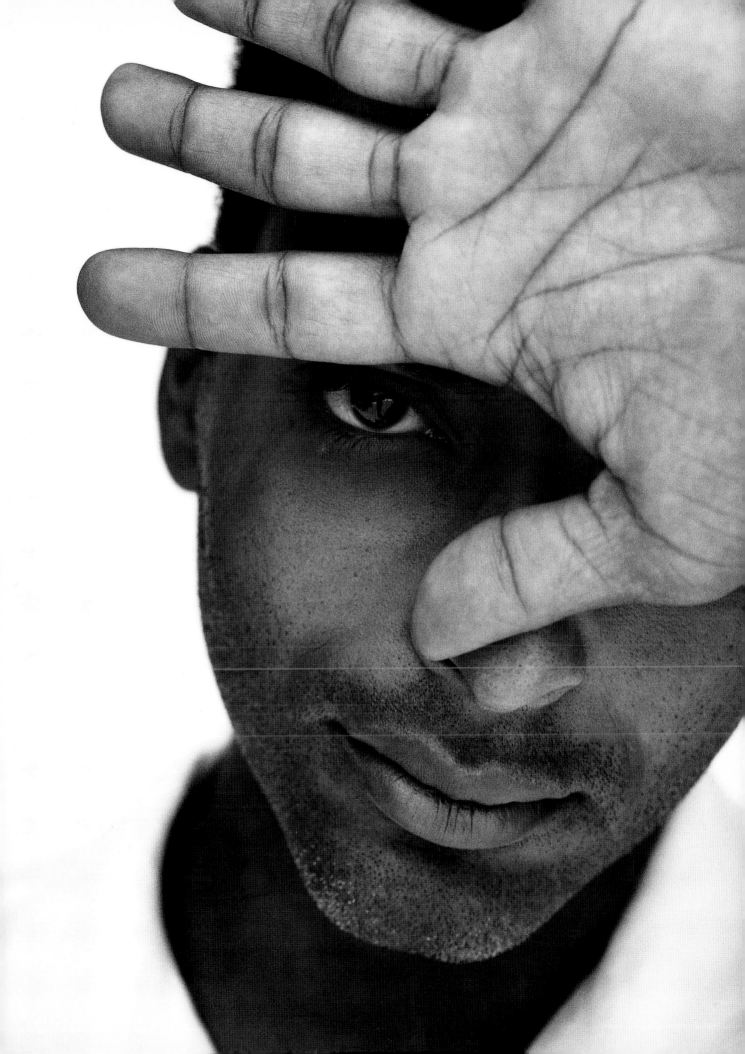

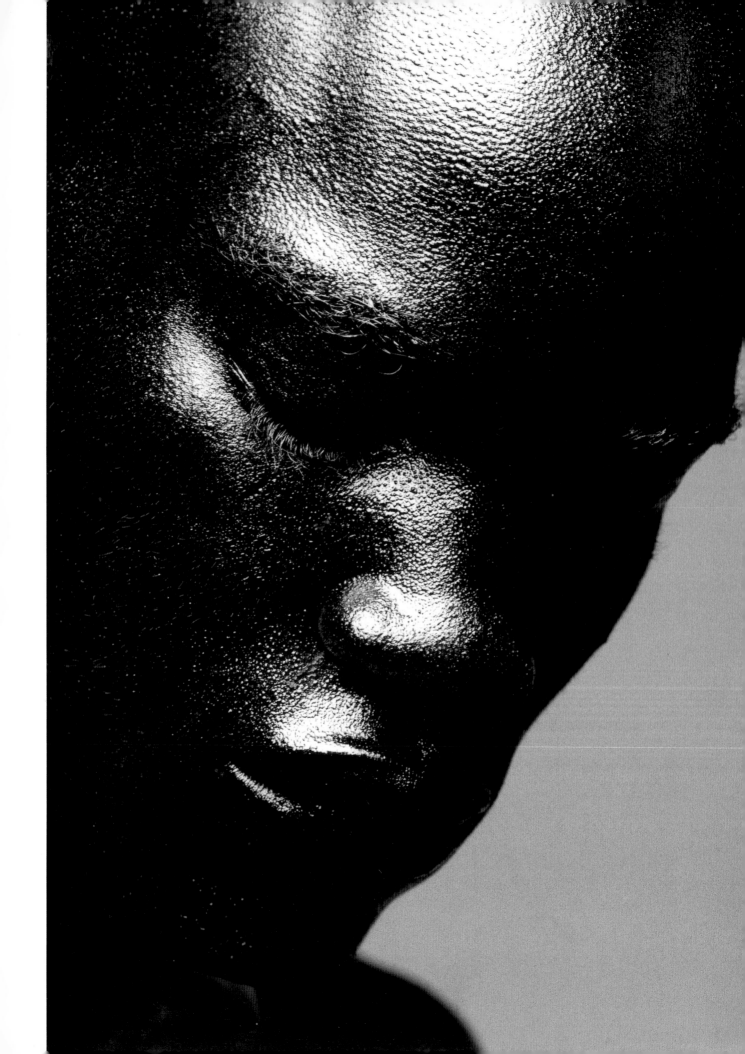

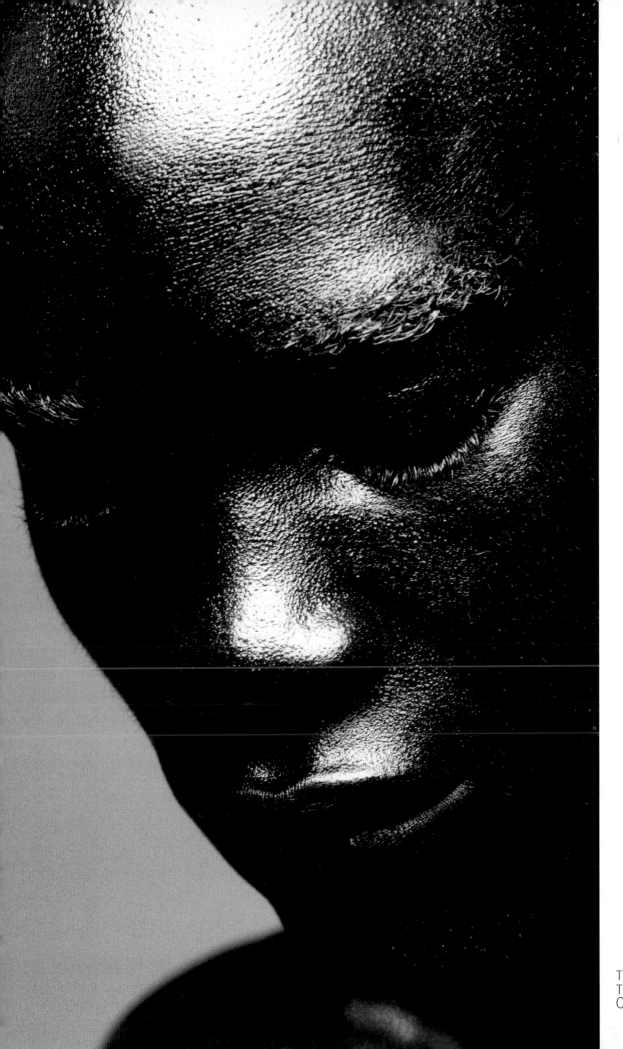

This, following pages:
Thierry Le Gouès
Charles, Charleton

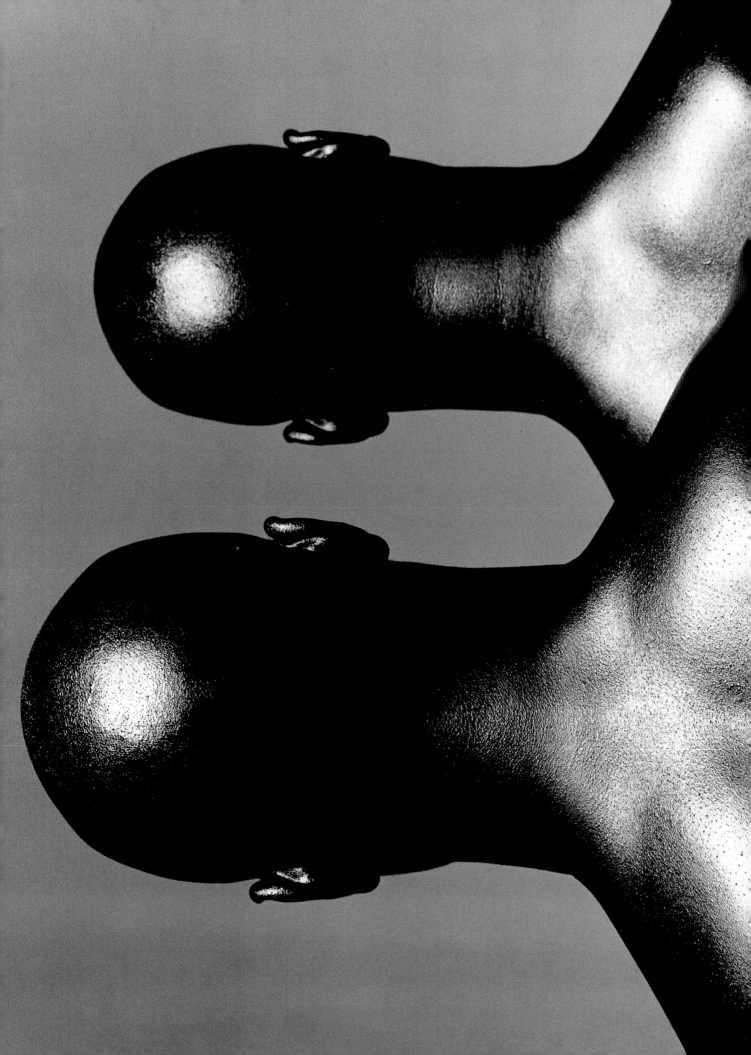

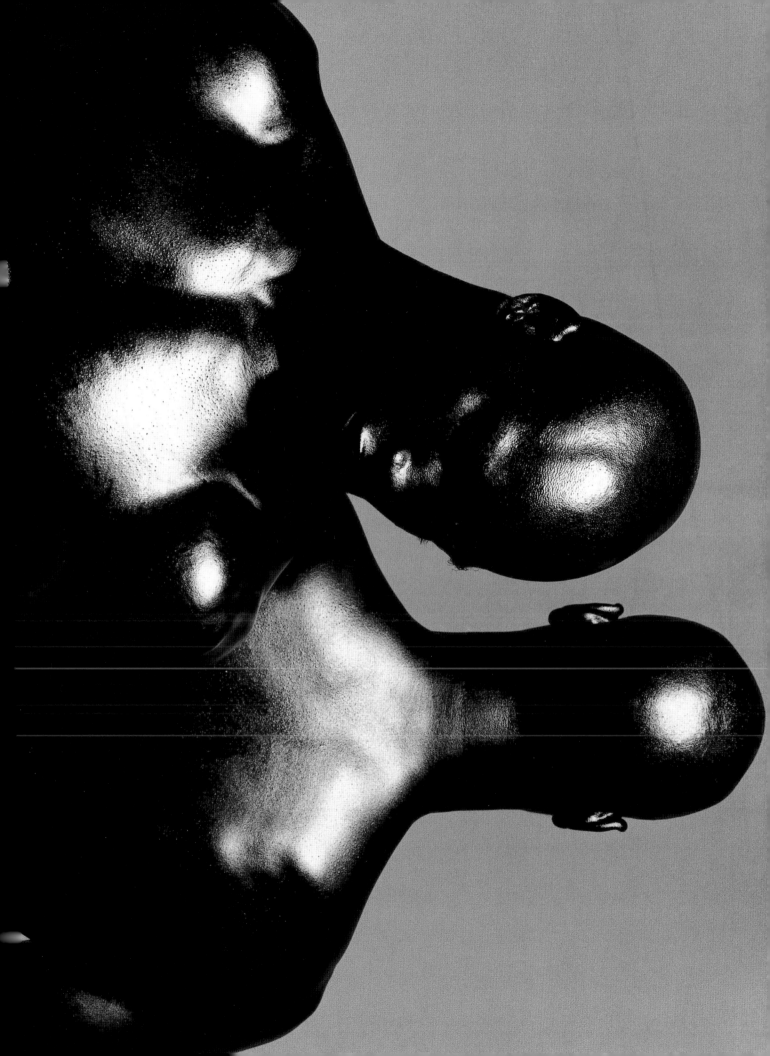

Marc Baptiste
Ajay

Black men are finally being portrayed in advertising as they really are—real brothers, not just the good-looking, smiling models.
—Cynthia Bailey, model

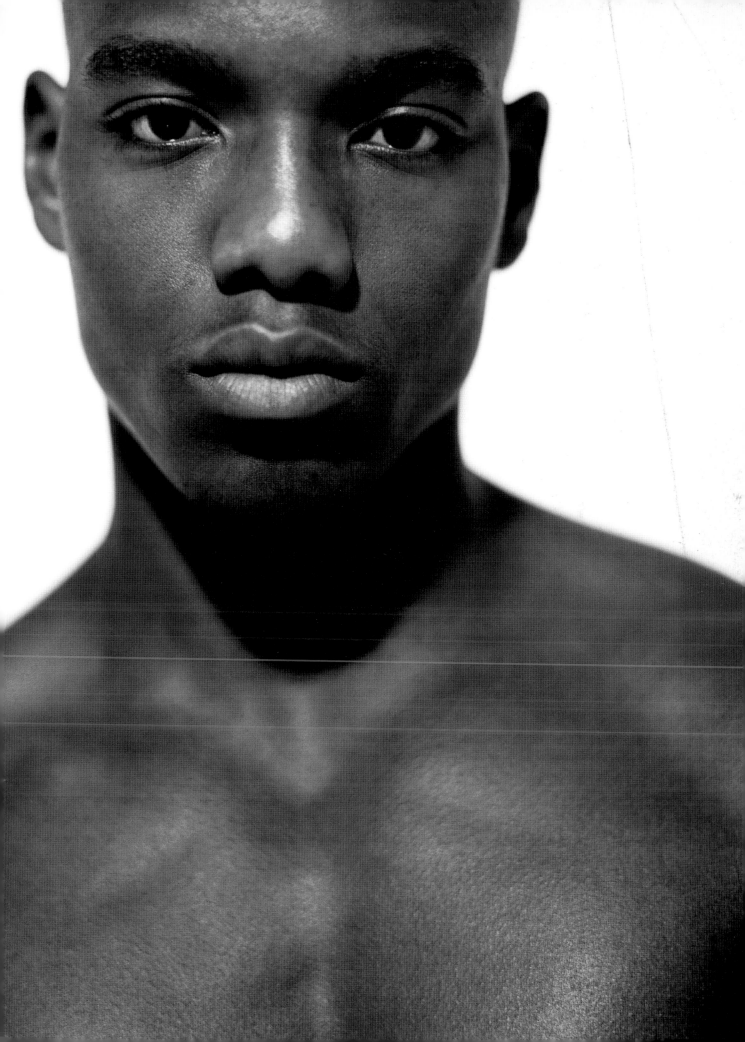

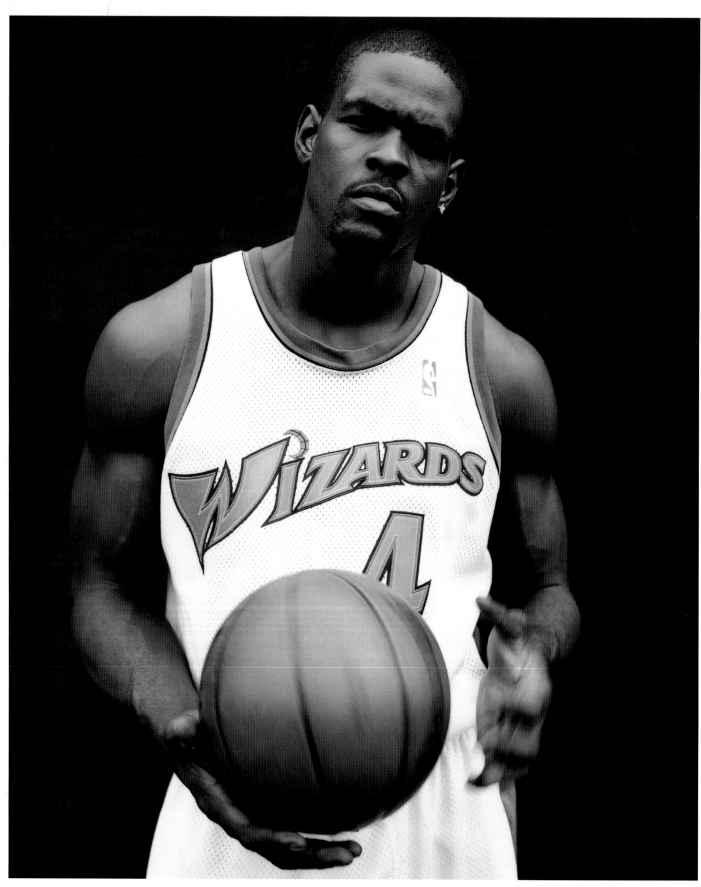

Left:
Jonathan Mannion
Chris Webber

Right:
Marc Baptiste
Treach

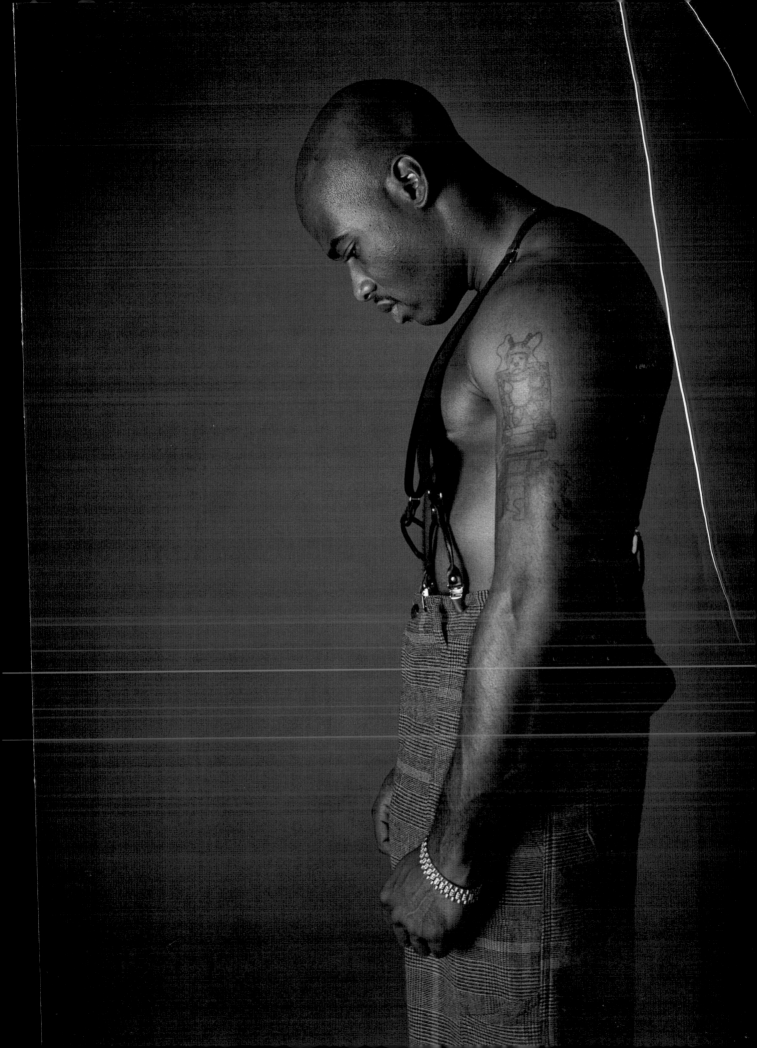

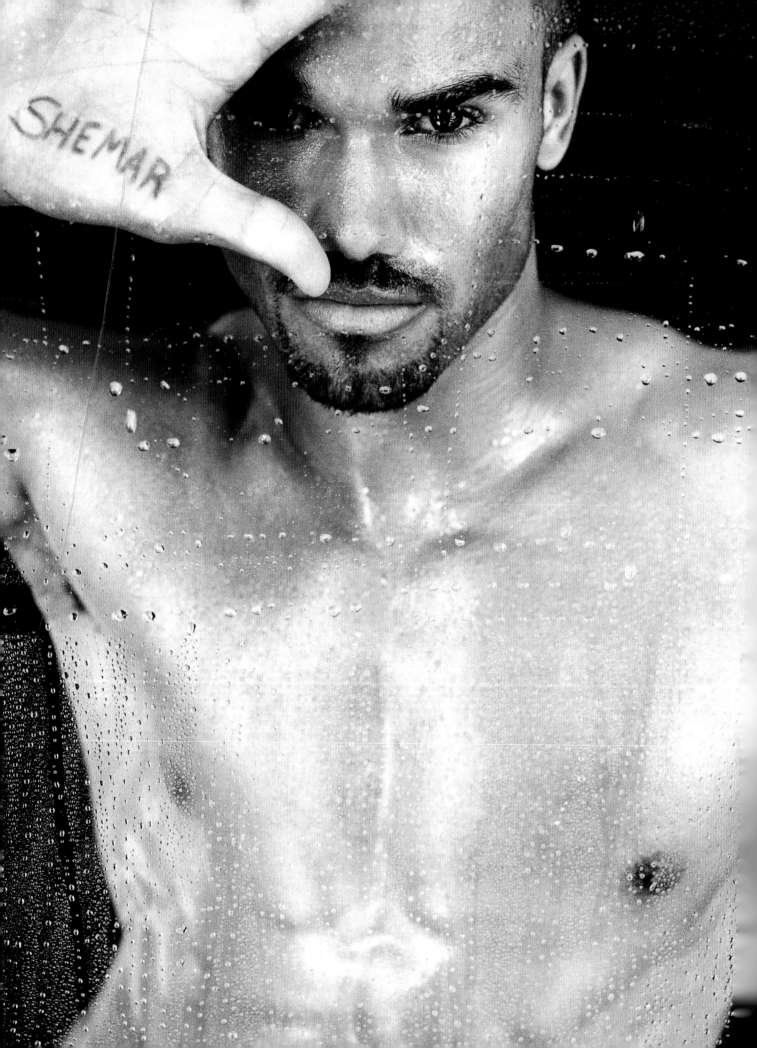

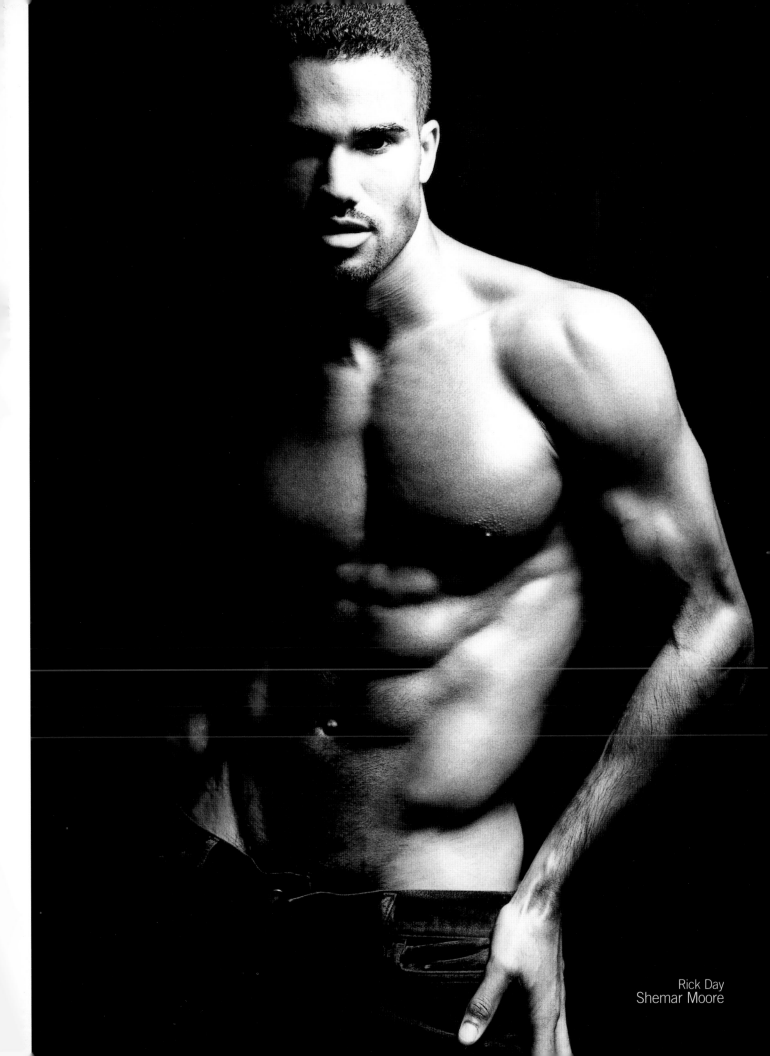

Rick Day
Shemar Moore

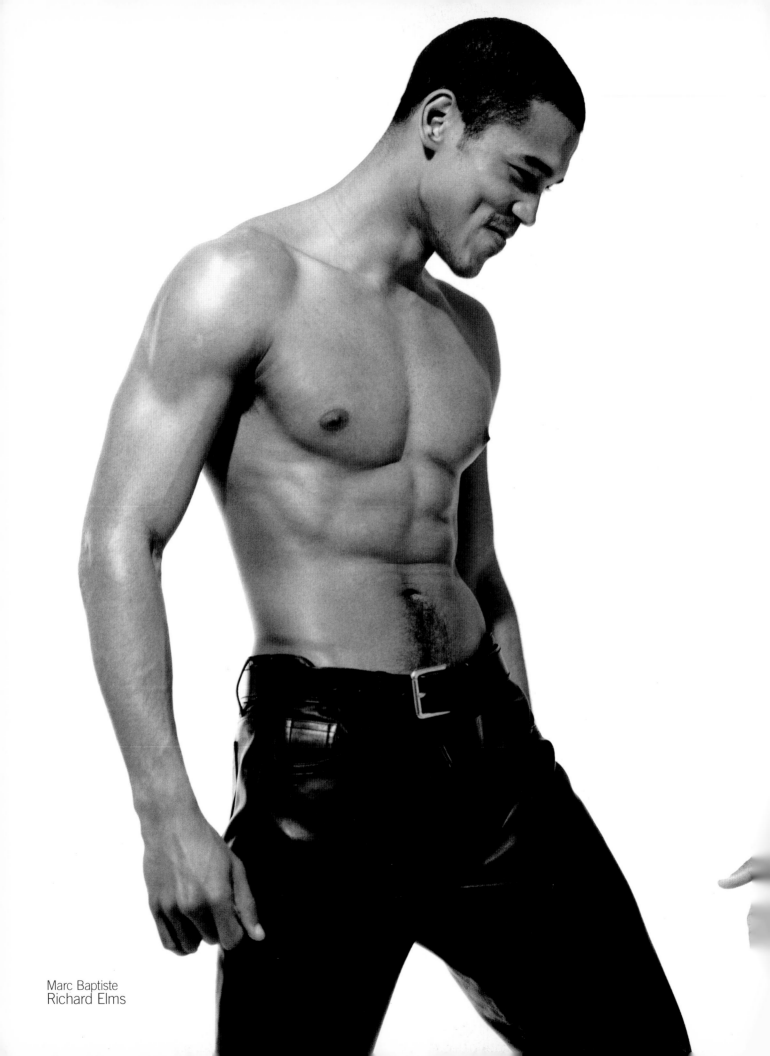

Marc Baptiste
Richard Elms

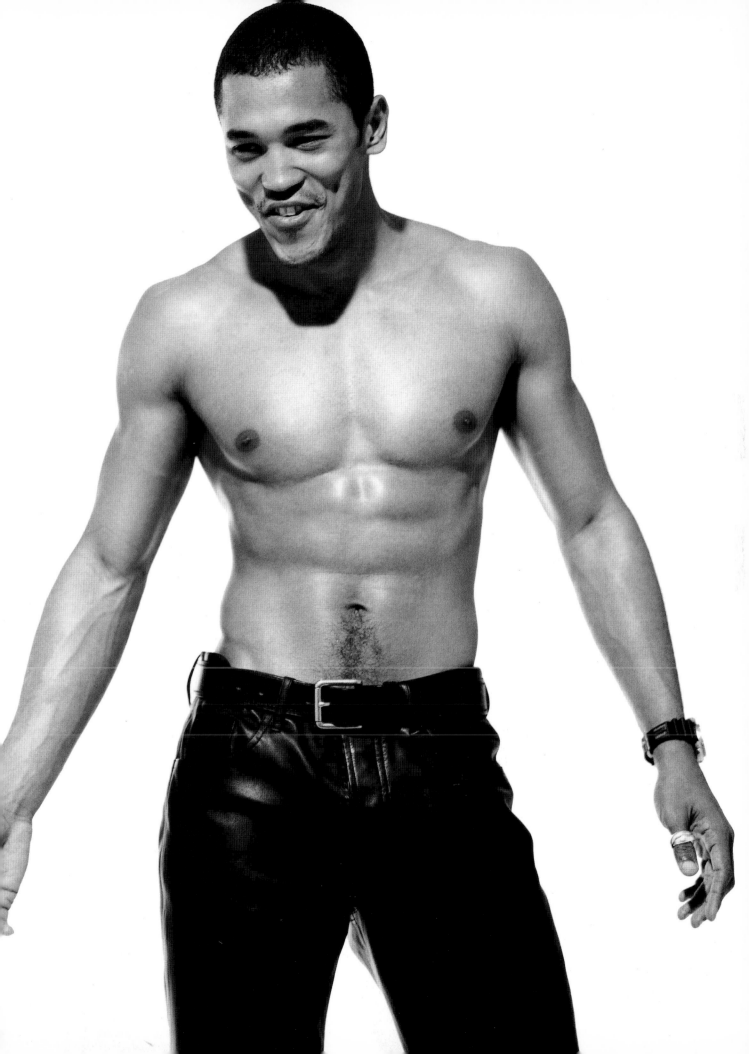

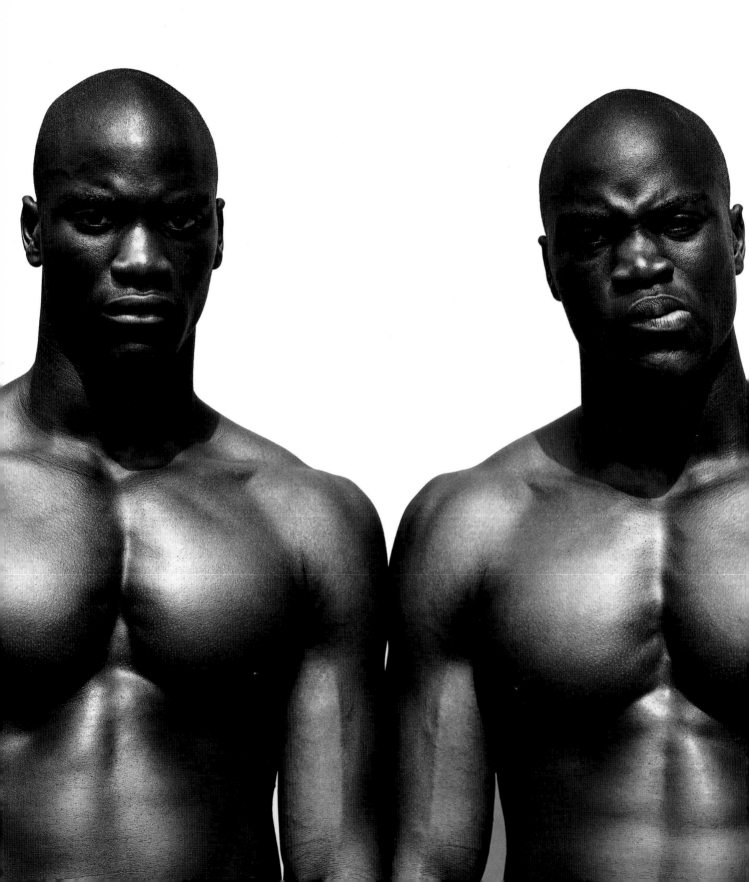

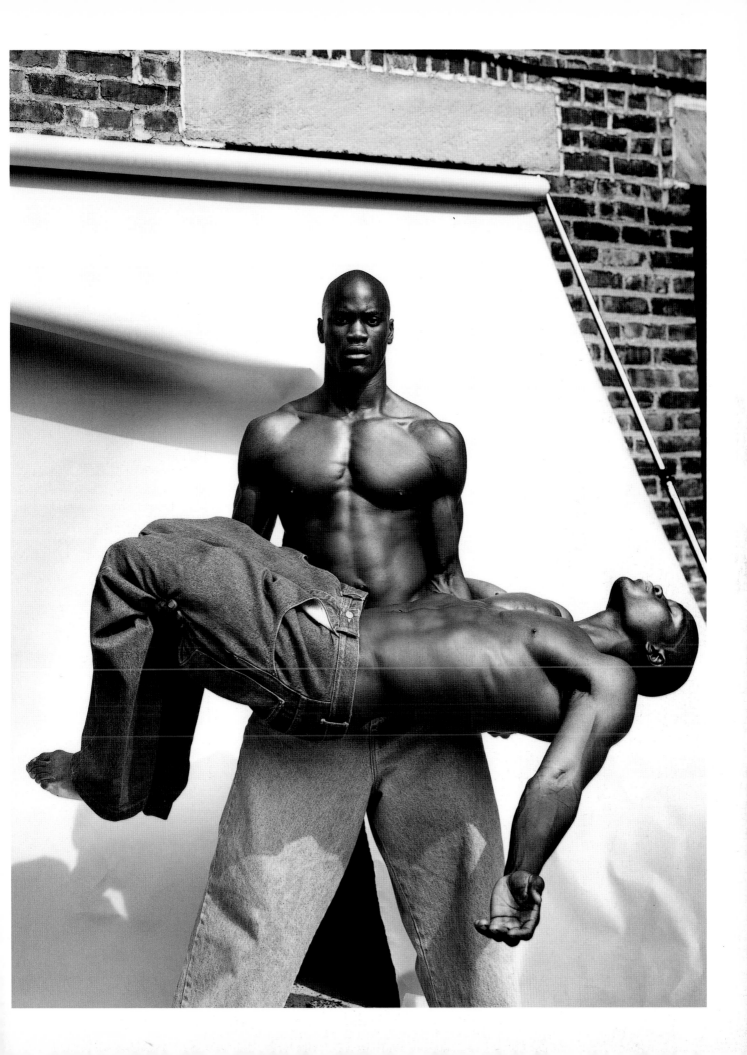

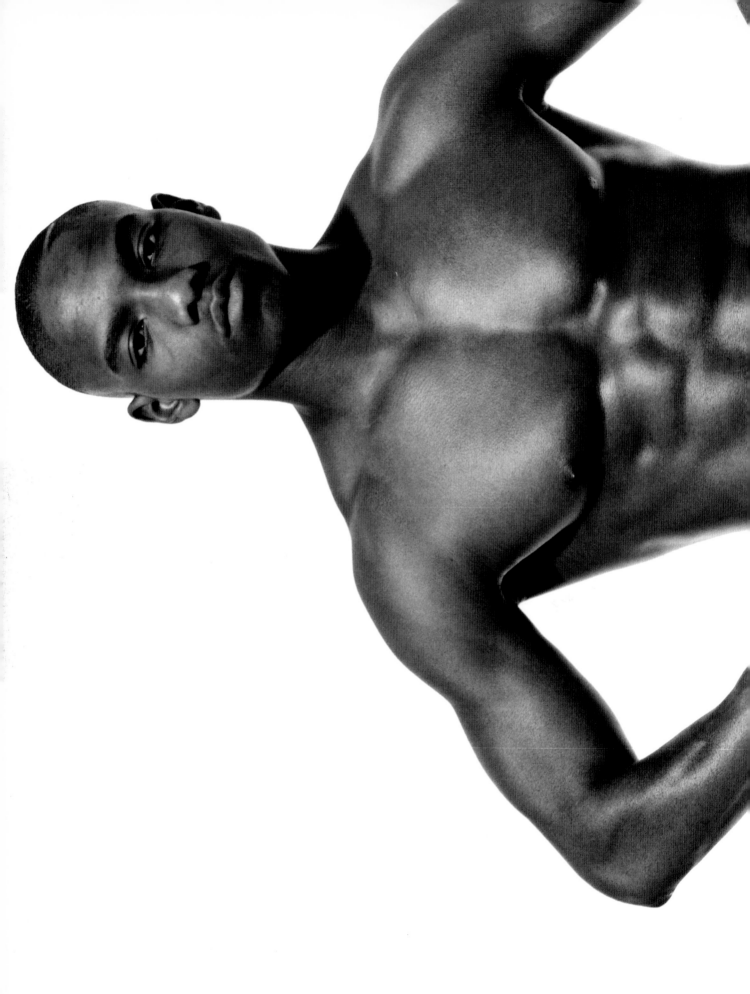

Marc Baptiste
Ajay

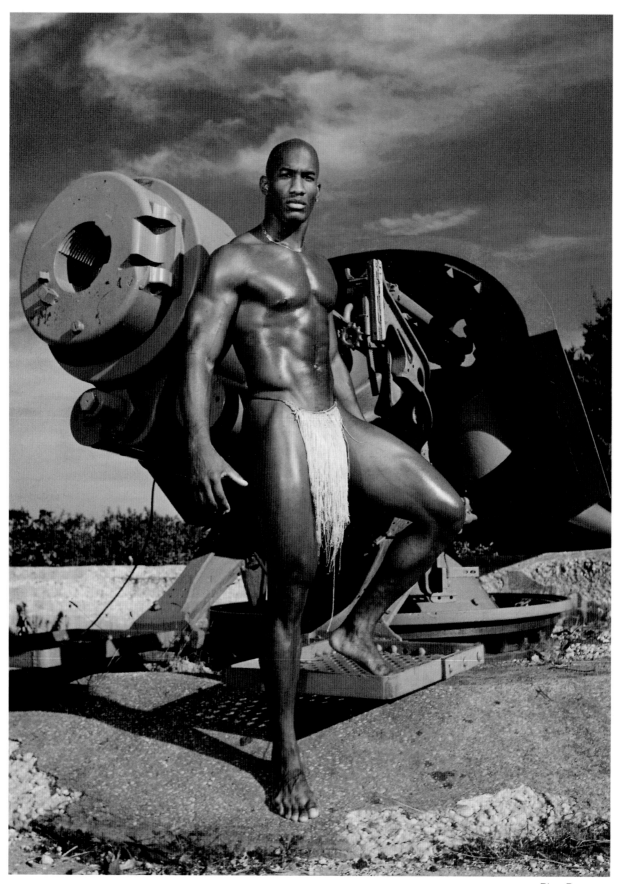

Ripp Bowman
Maurice Lawrence

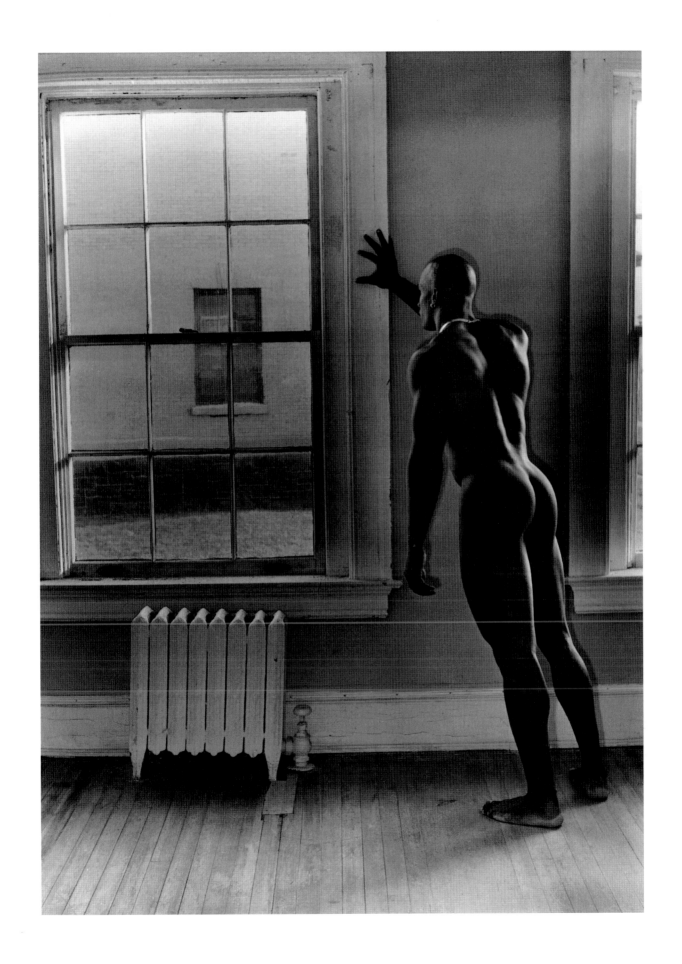

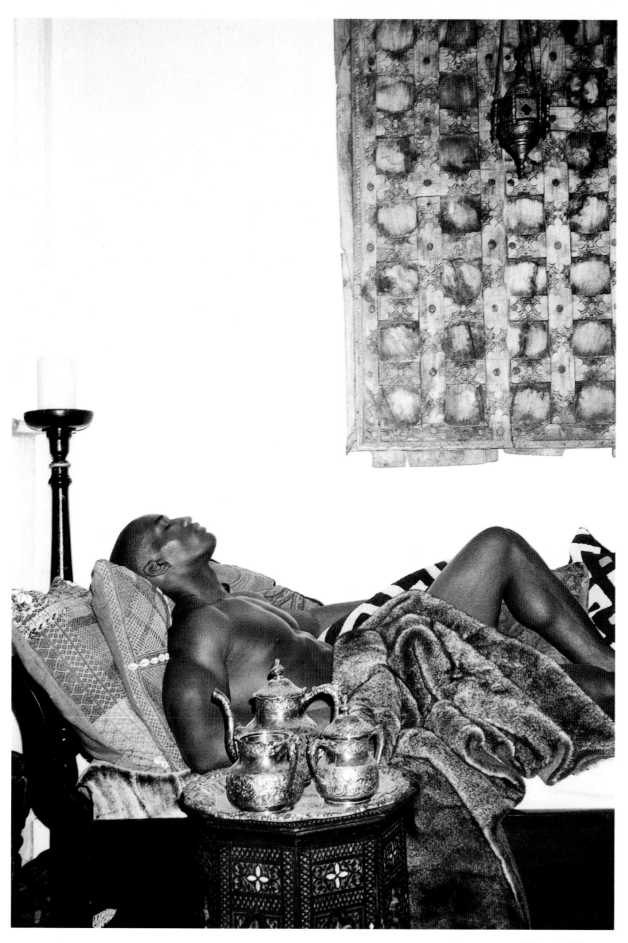

Edward Wilkerson
Maurice Lawrence

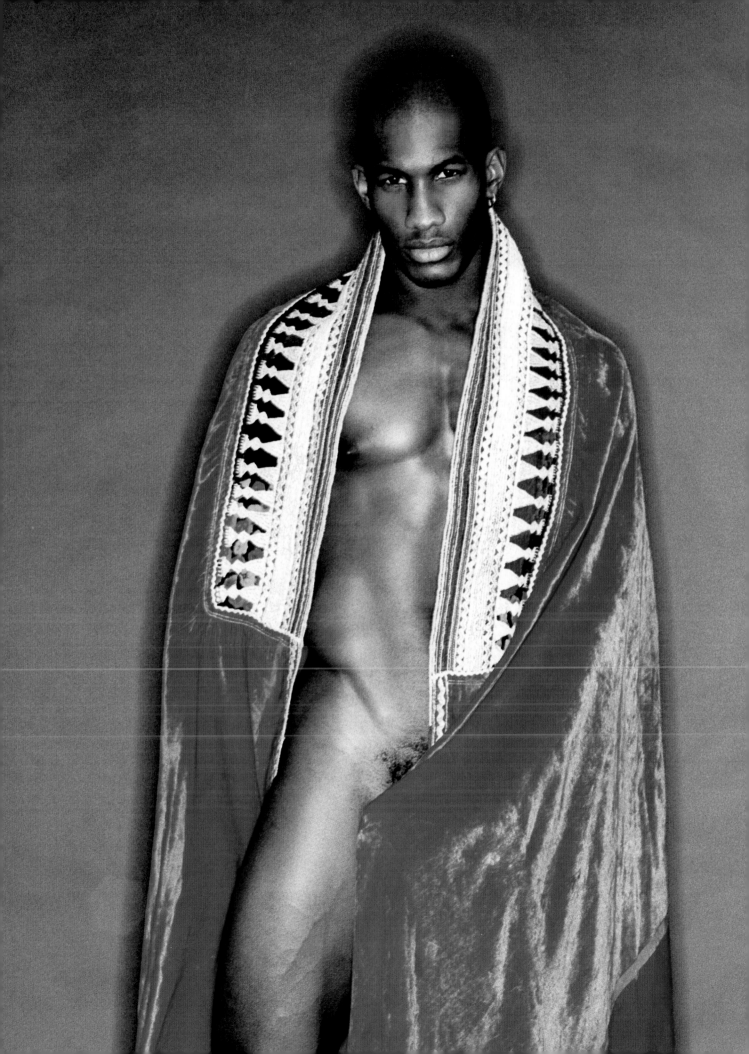

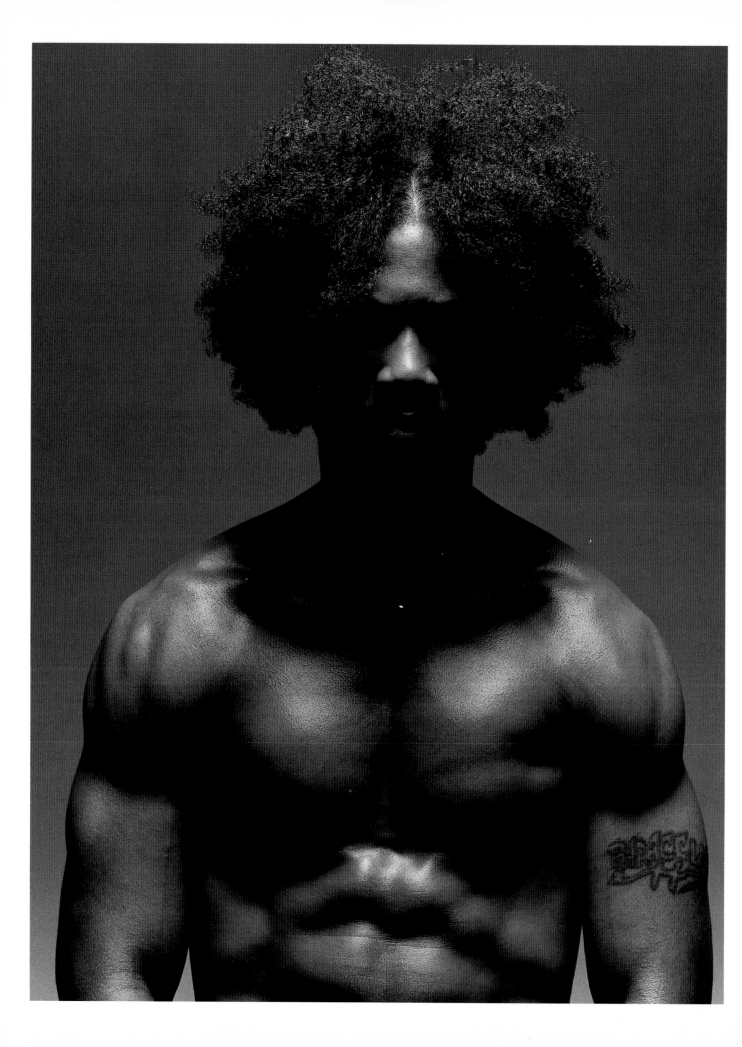

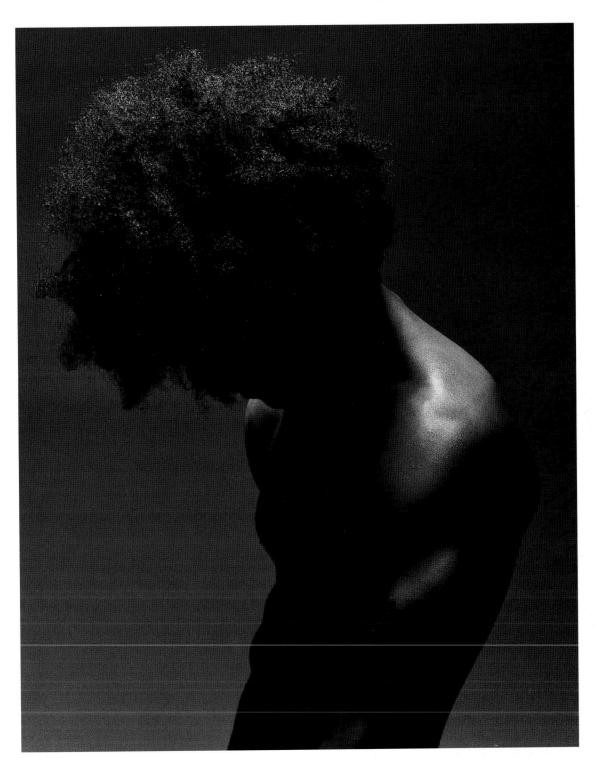

Thierry Le Gouès
Unknown

# Hair has always been an important ingredient in black men's style. We've always been expressive with it.
—Lanier Long, makeup artist

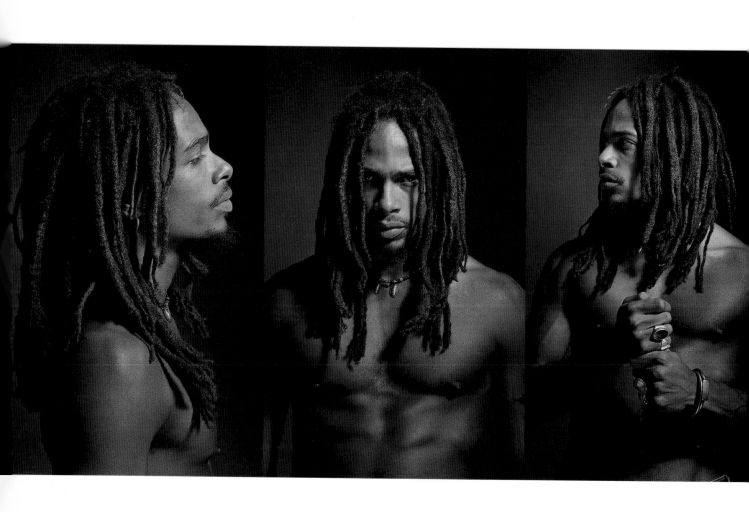

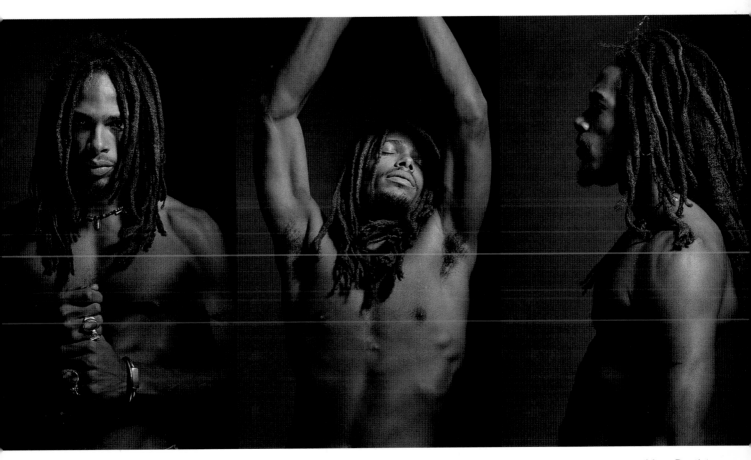

Marc Baptiste
Gary Dourdan

Edward Wilkerson
Eric Snell

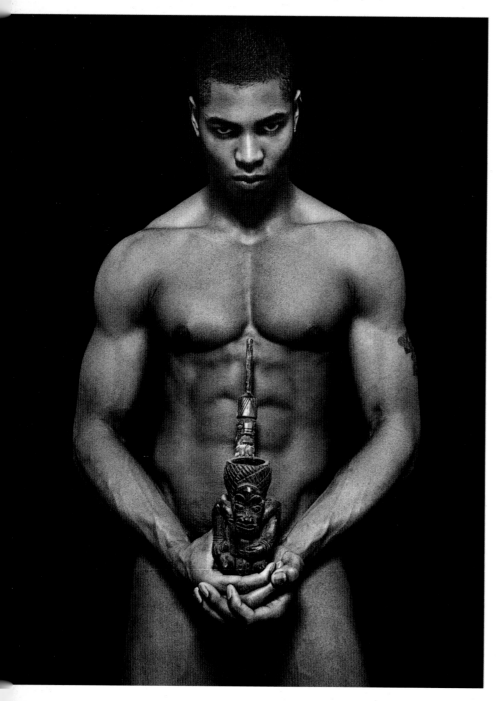

Gary is the
epitome of
black **male**
**beauty.**
—Julius Poole,
creative editor

Pablo Ravazzani
Gary Dourdan

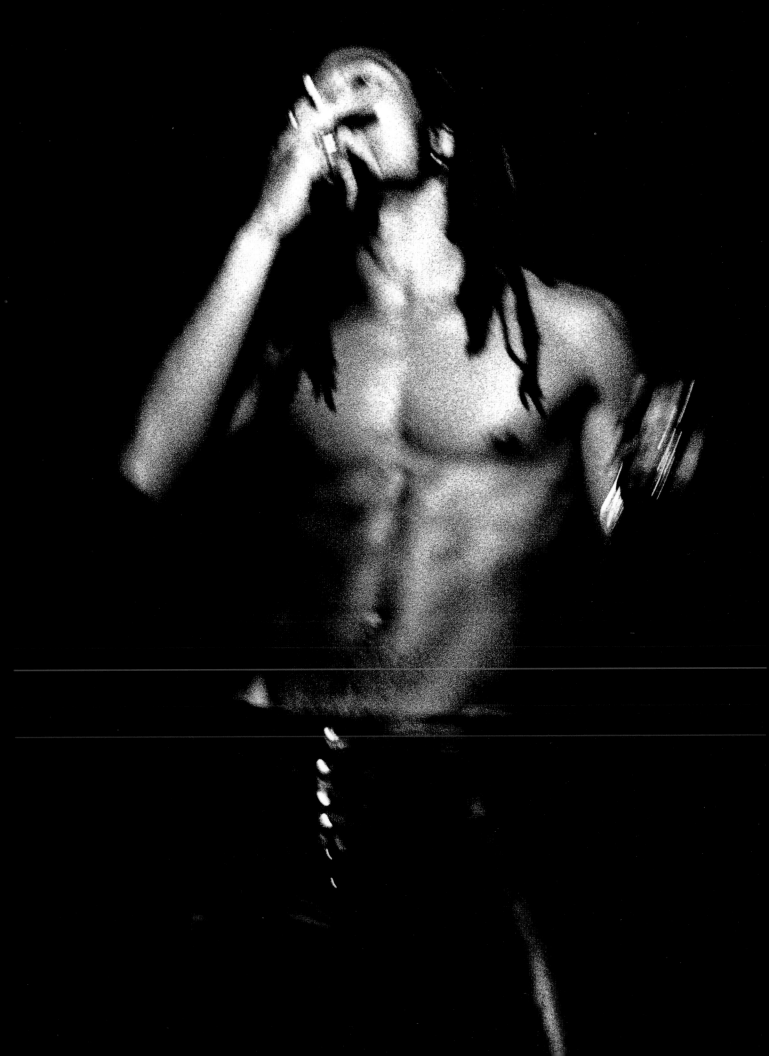

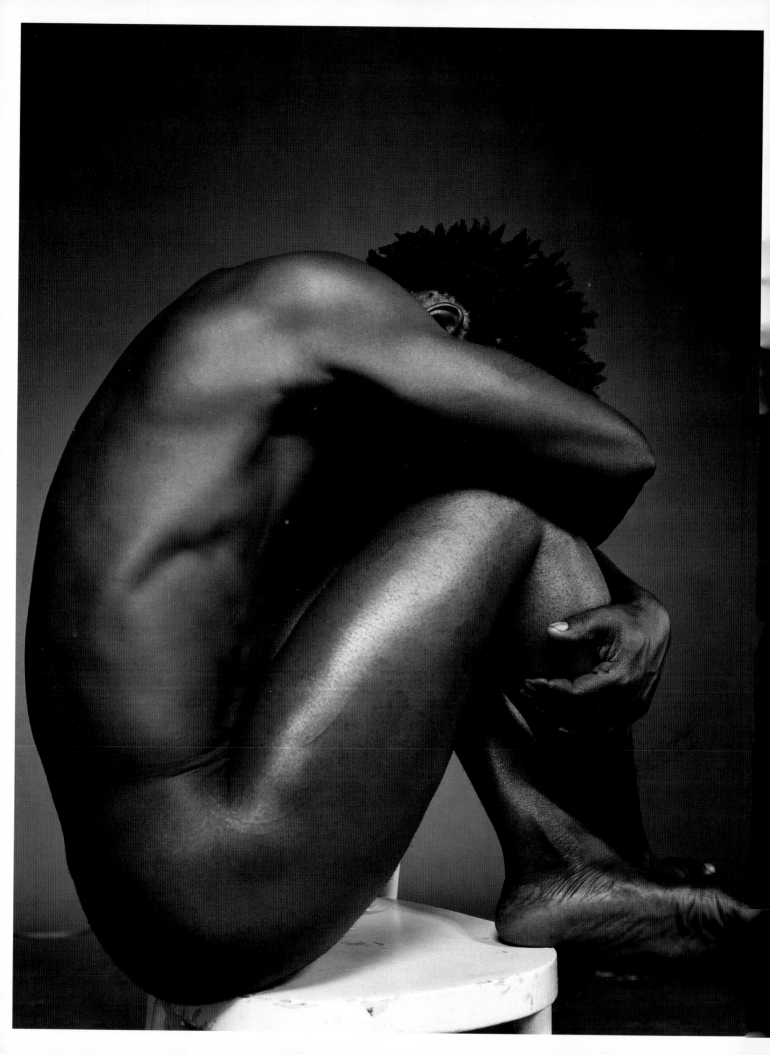

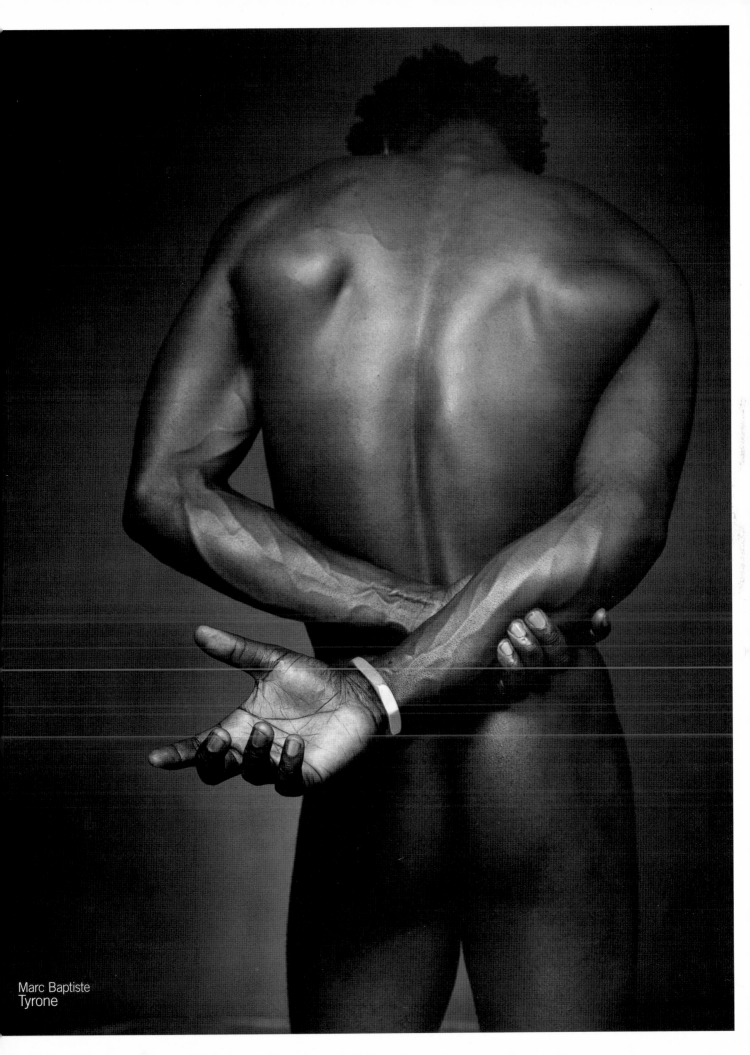

Marc Baptiste
Tyrone

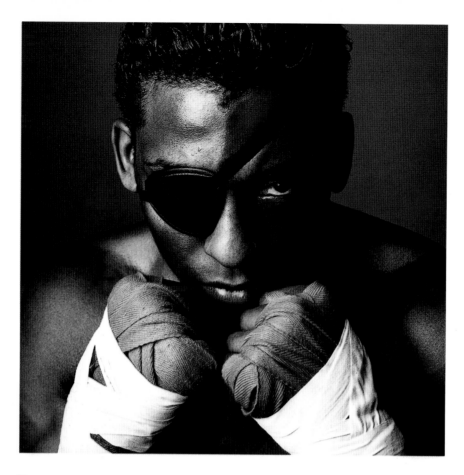

Top:
Jesse Frohman
Michael Olajide

Bottom:
Geoffroy de Boismenu
Alex Ochoa

Right:
Jesse Frohman
Michael Olajide

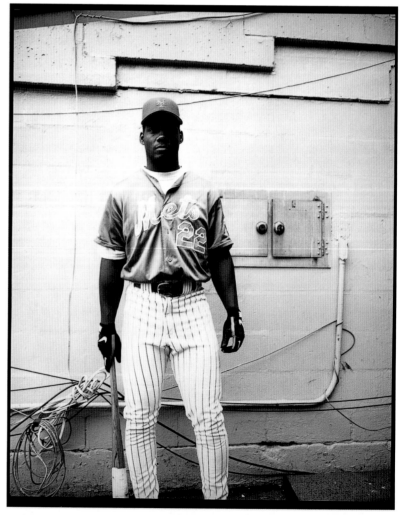

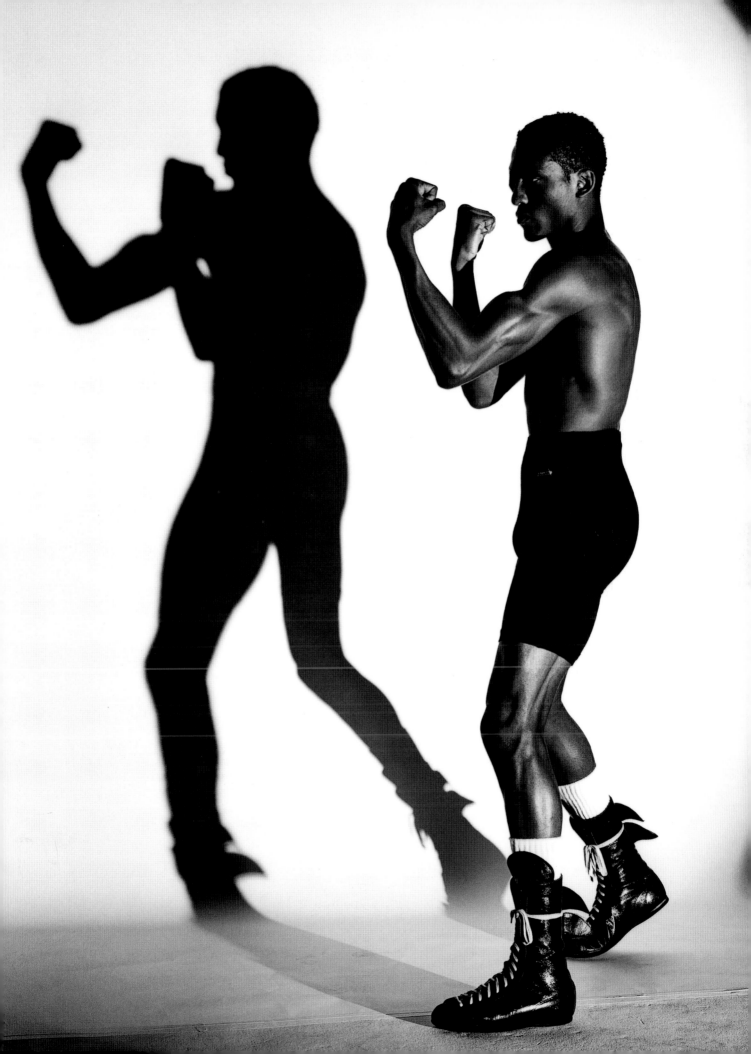

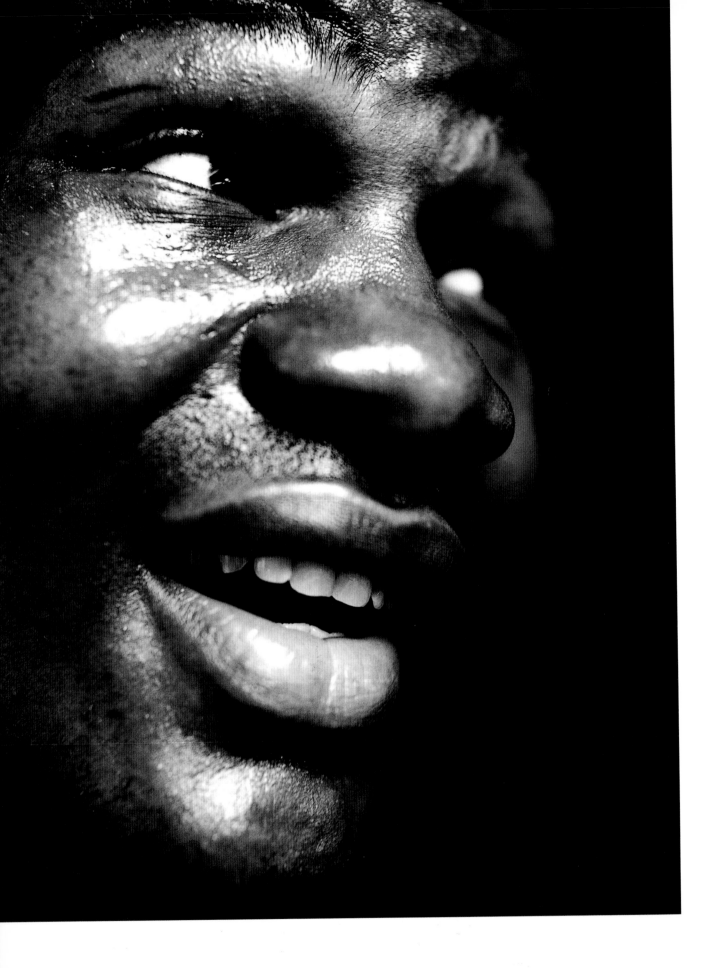

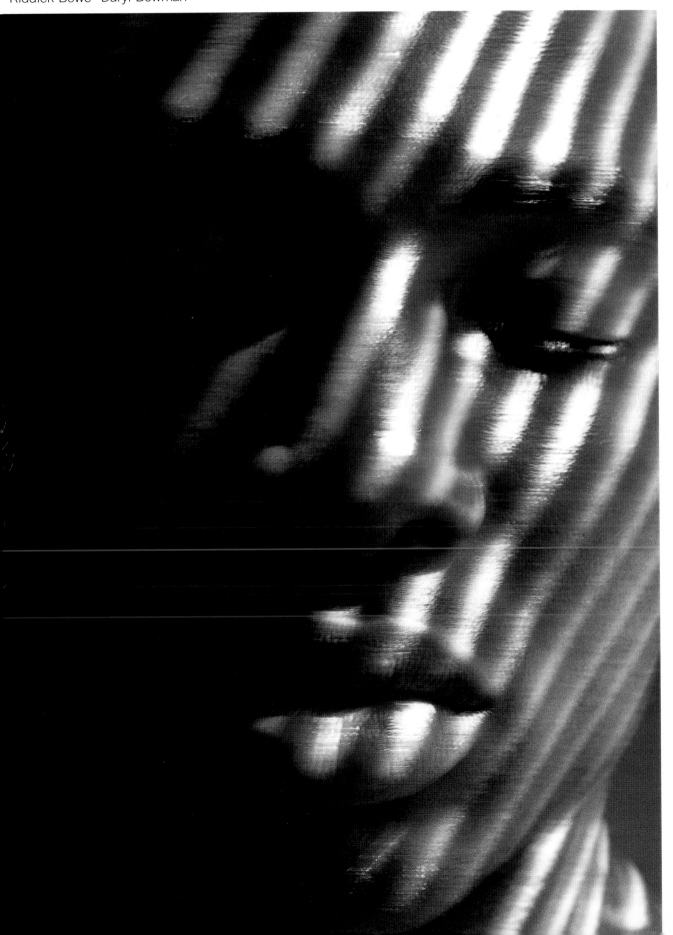

Walter Chin
Rob Moore

# Black

men create their own style. They don't go by what fashion dictates or by what Madison Avenue tells them.
—Dawn Baskerville, *In Style*

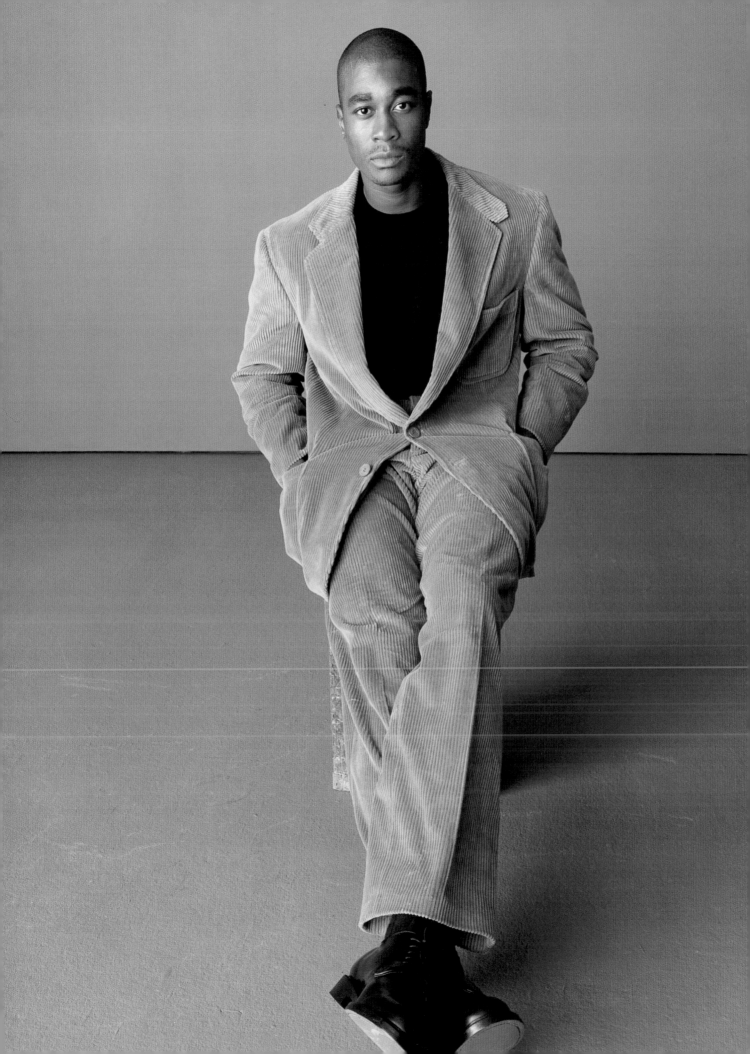

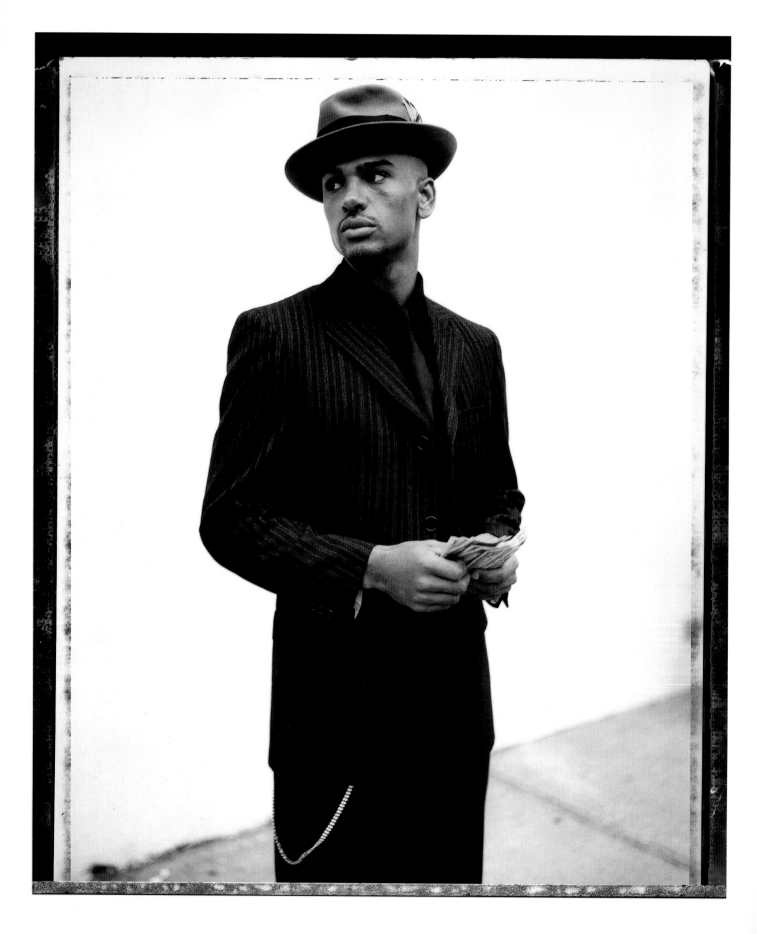

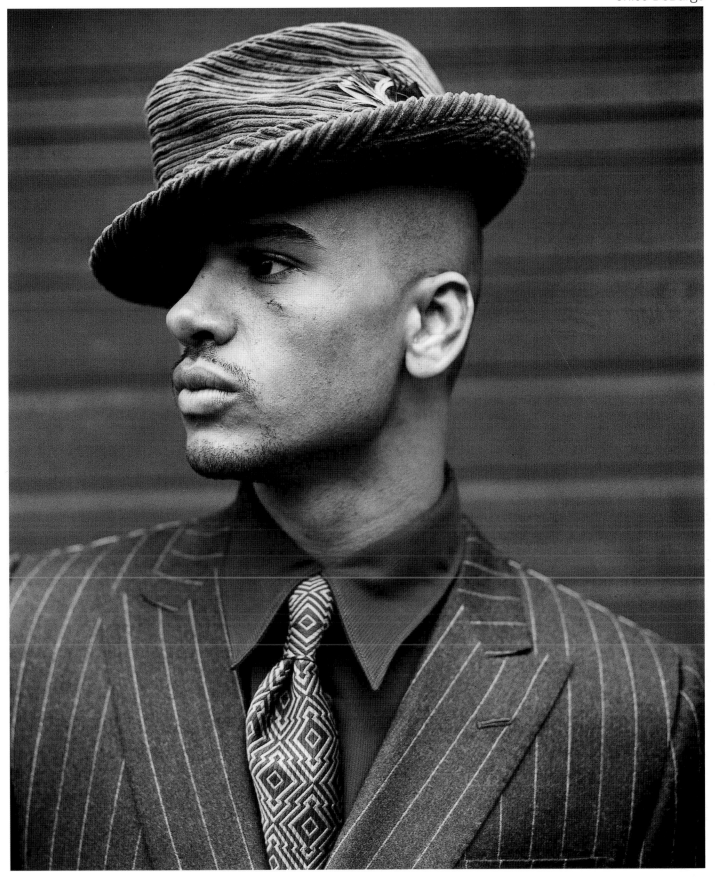

Jonathan Mannion
Chico DeBarge

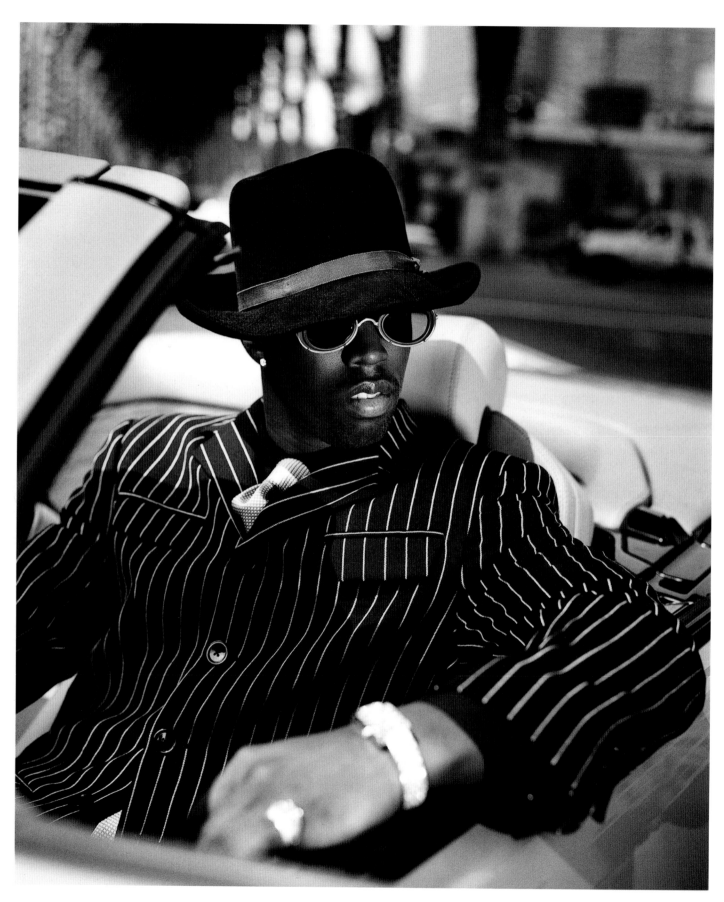

Marc Baptiste
Sean "Puffy" Combs

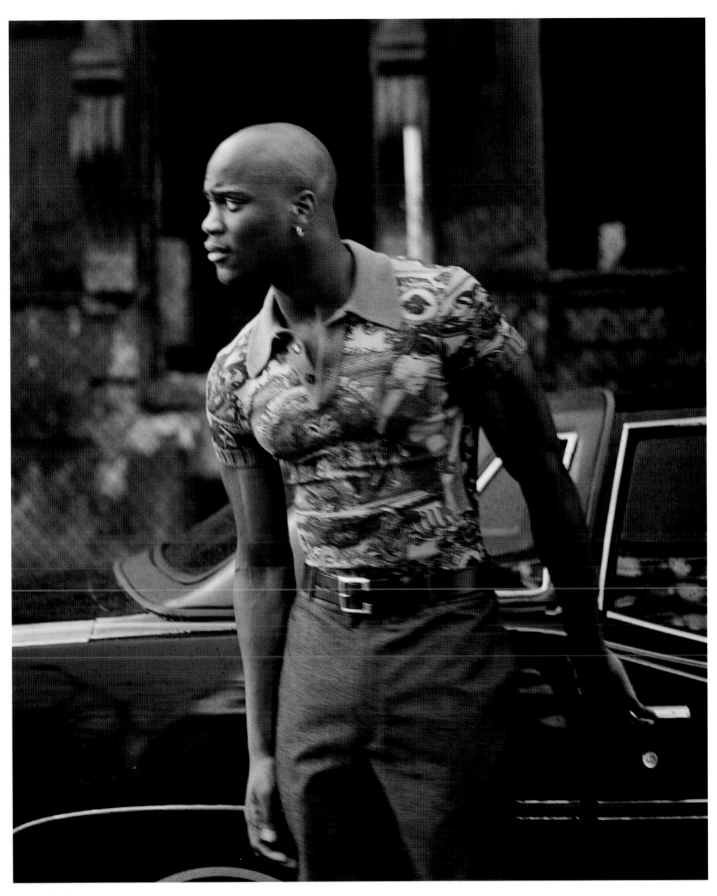

Marc Baptiste
Charles

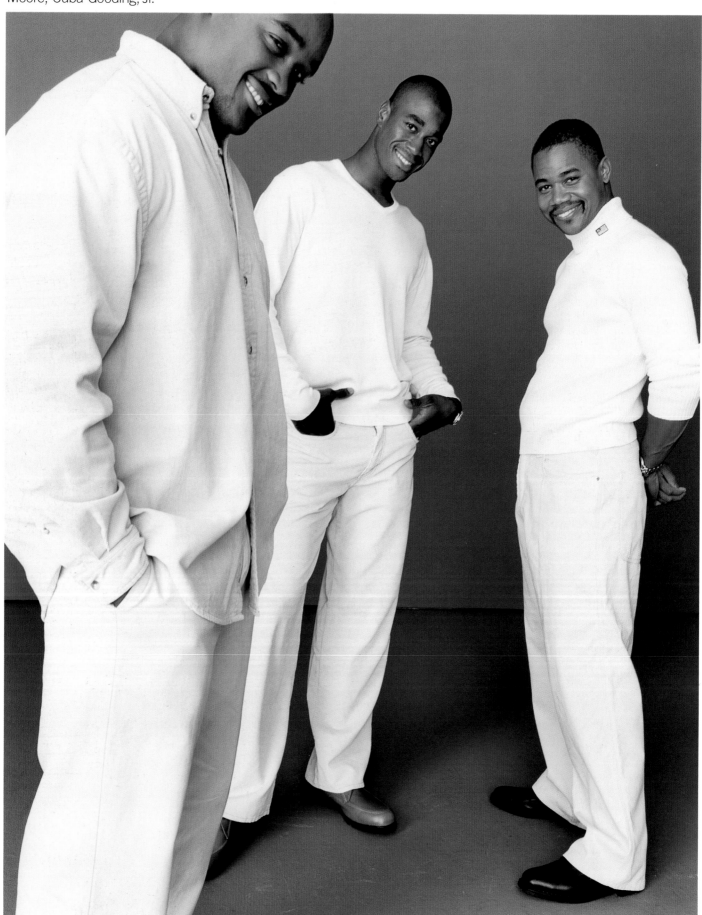

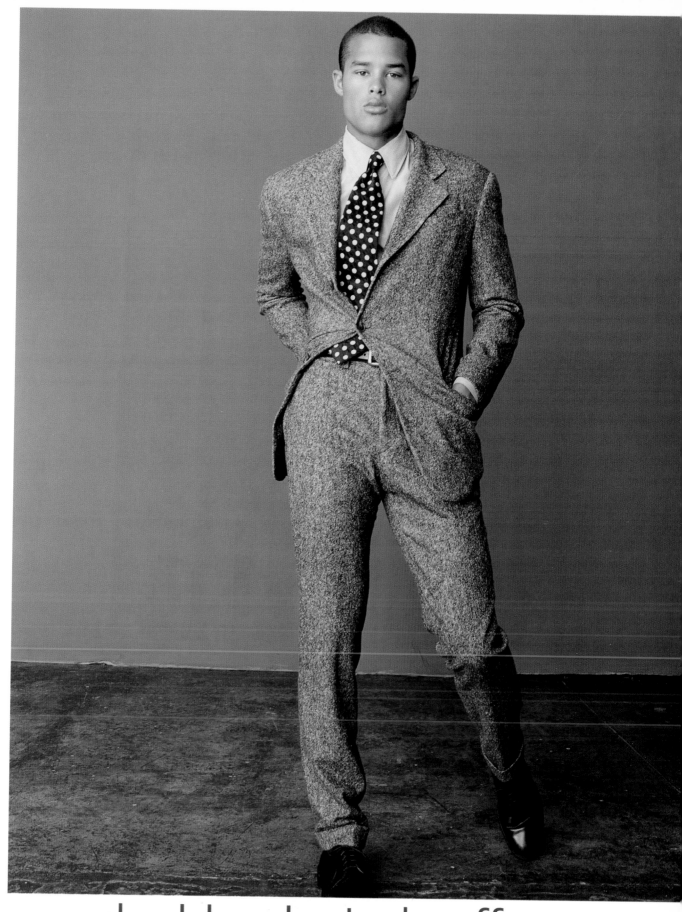

The double-pleated cuff pant with a good shoe is a signature of black male style.
—Renee Sheffey-Brown, *Essence*

Norman Jean Roy
Chris Rock

With black men, it's clearly a case of the man making the clothes.
—Emil Wilbekin, *Vibe*

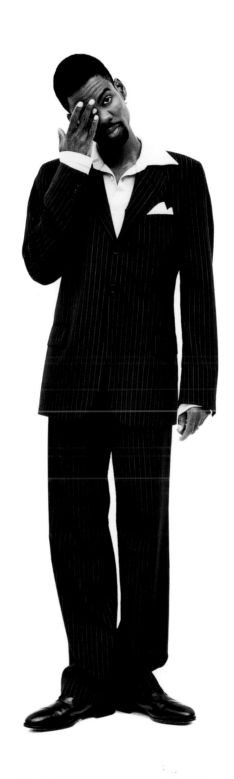

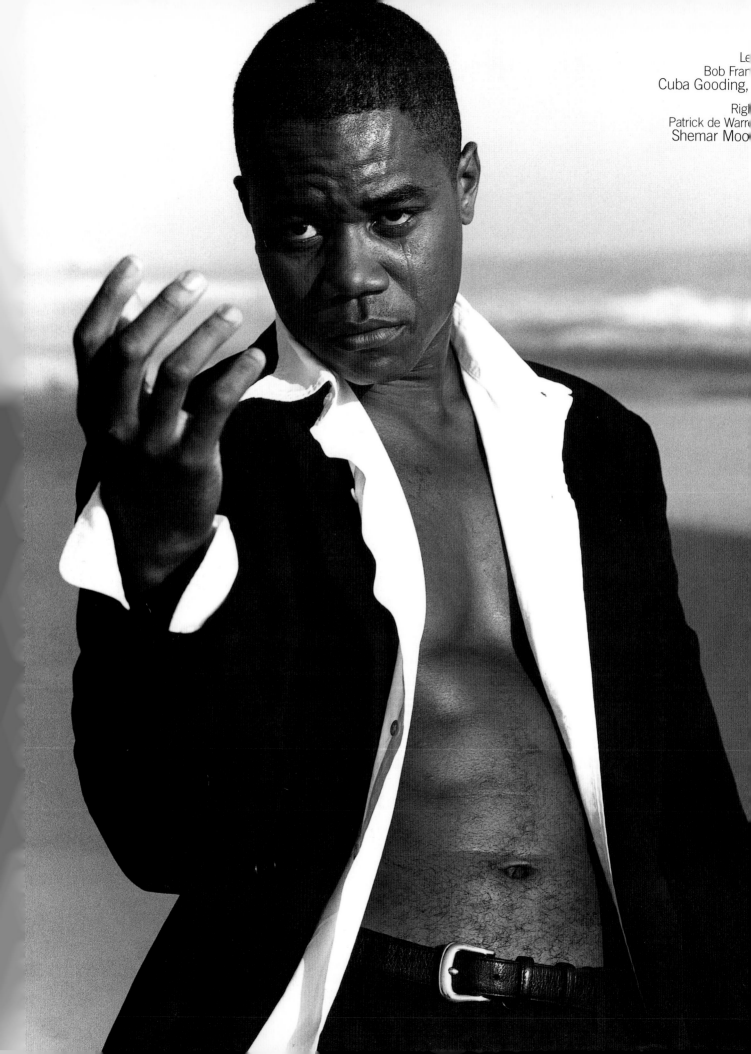

Le
Bob Fra
Cuba Gooding,

Rig
Patrick de Warr
Shemar Moo

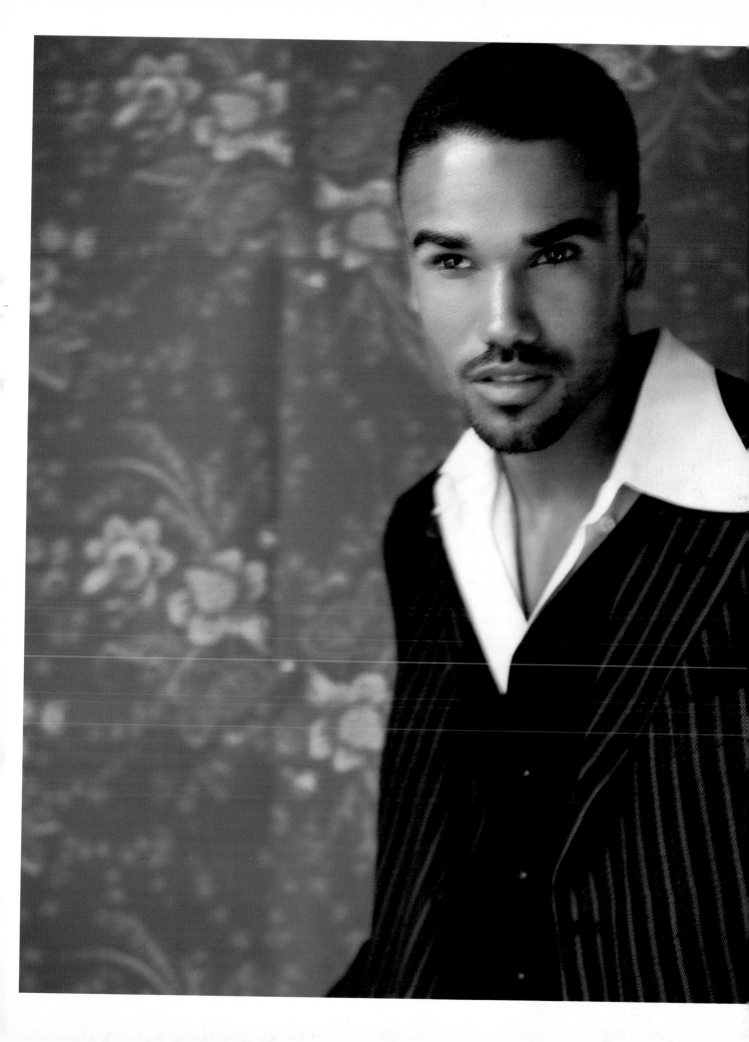

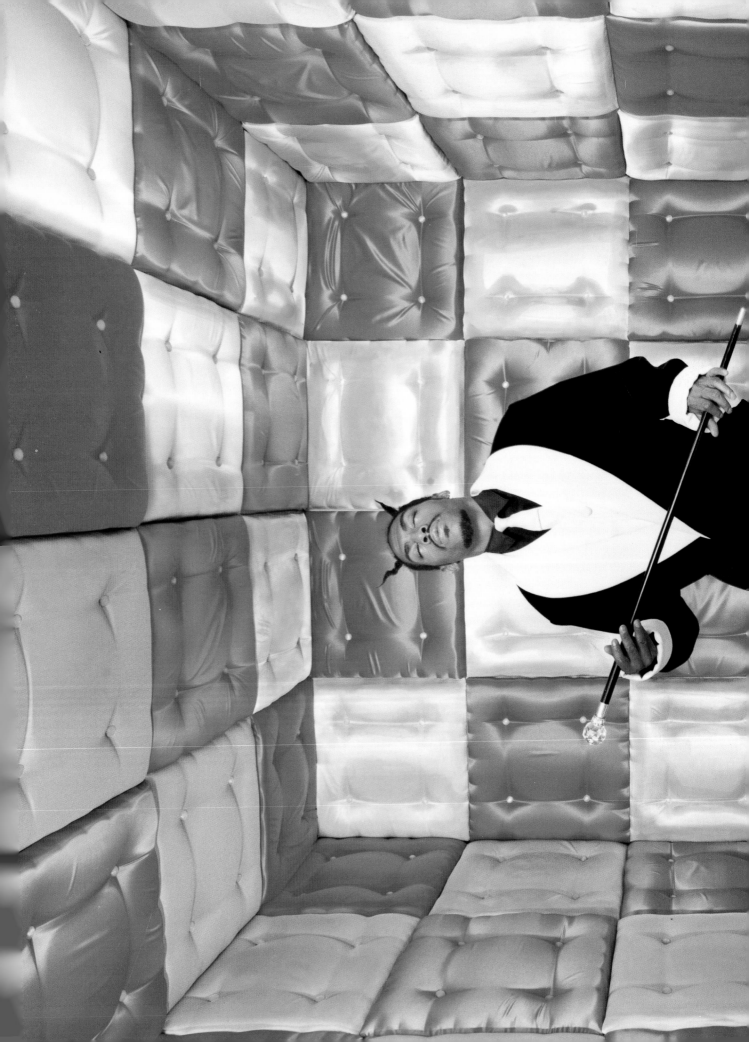

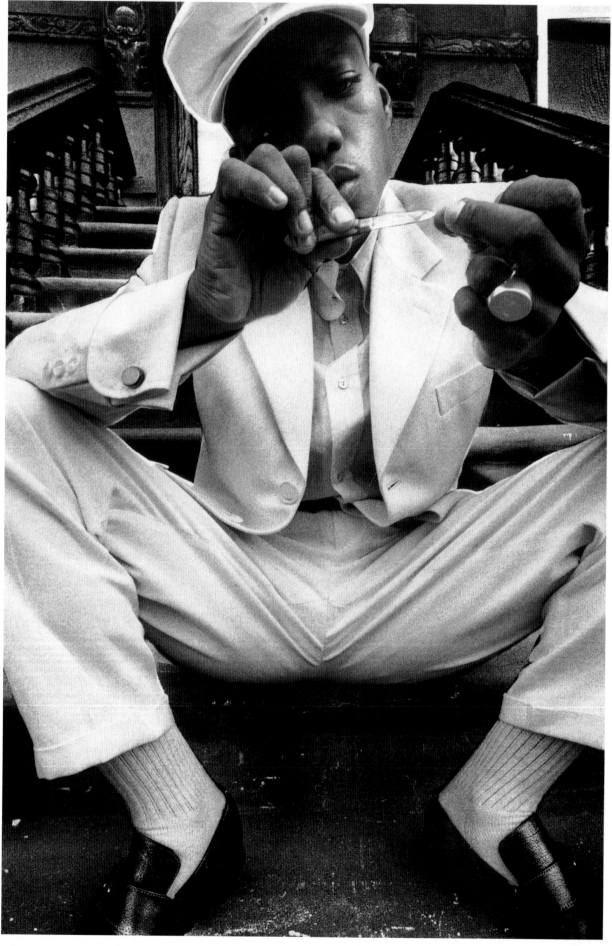

Platon
Ajay

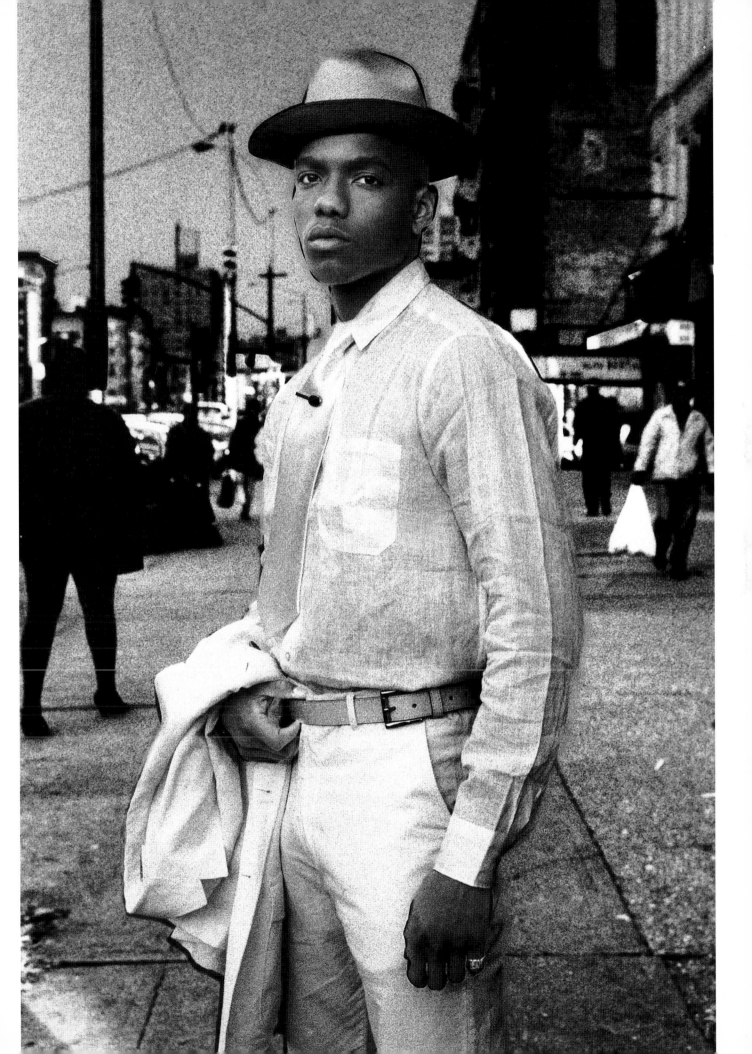

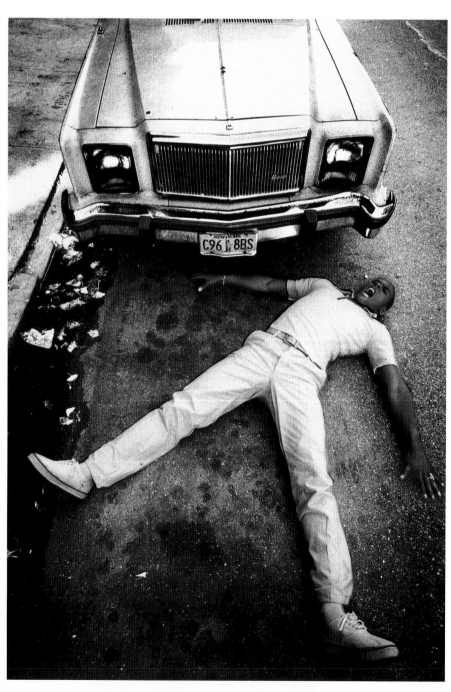

Platon
Crush

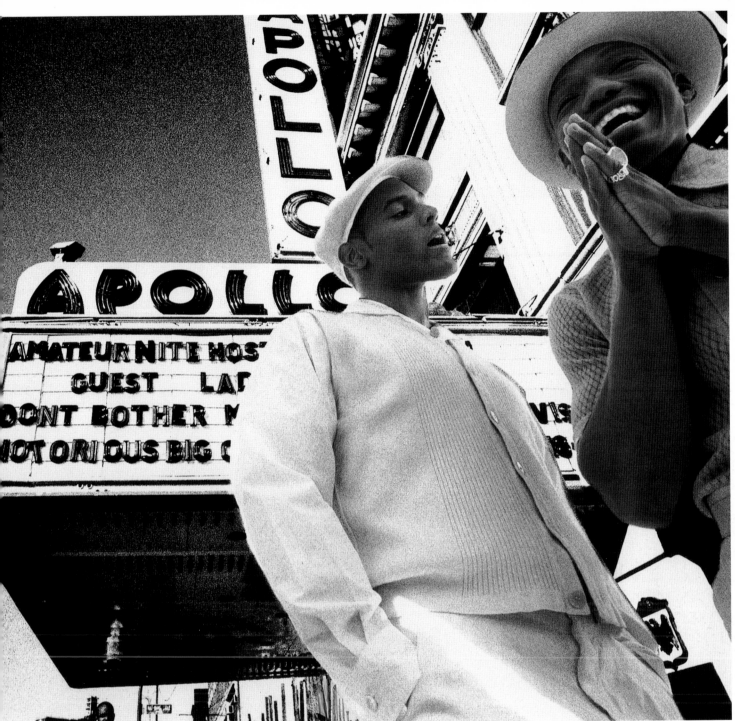

Platon
Crush, Ajay

While mainstream trendsetters of the 1960s created a whole fashion genre out of the sloppy look, black folks just weren't having it. They were relating to Sidney Poitier, Harry Belafonte, James Baldwin, and Marvin Gaye.
—Richard Reid, writer

No influence has shaped black men's fashions during the 20th century as much as the style that's come out of the jazz world.
—Susan Taylor, *Essence*

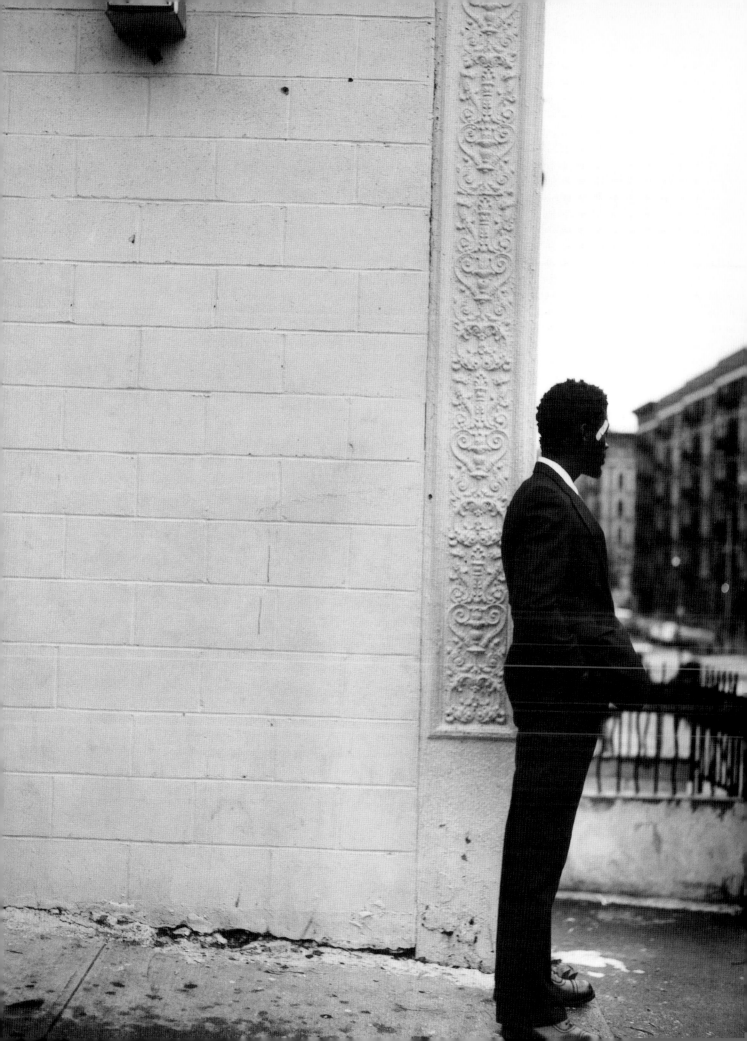

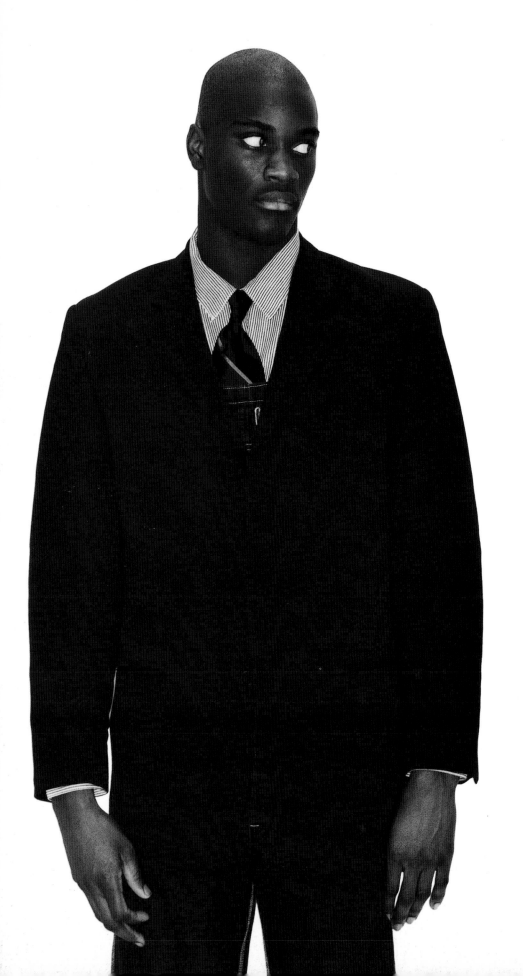

Left:
Marc Baptiste
Charleton

Right:
Jonathan Mannion
Unknown

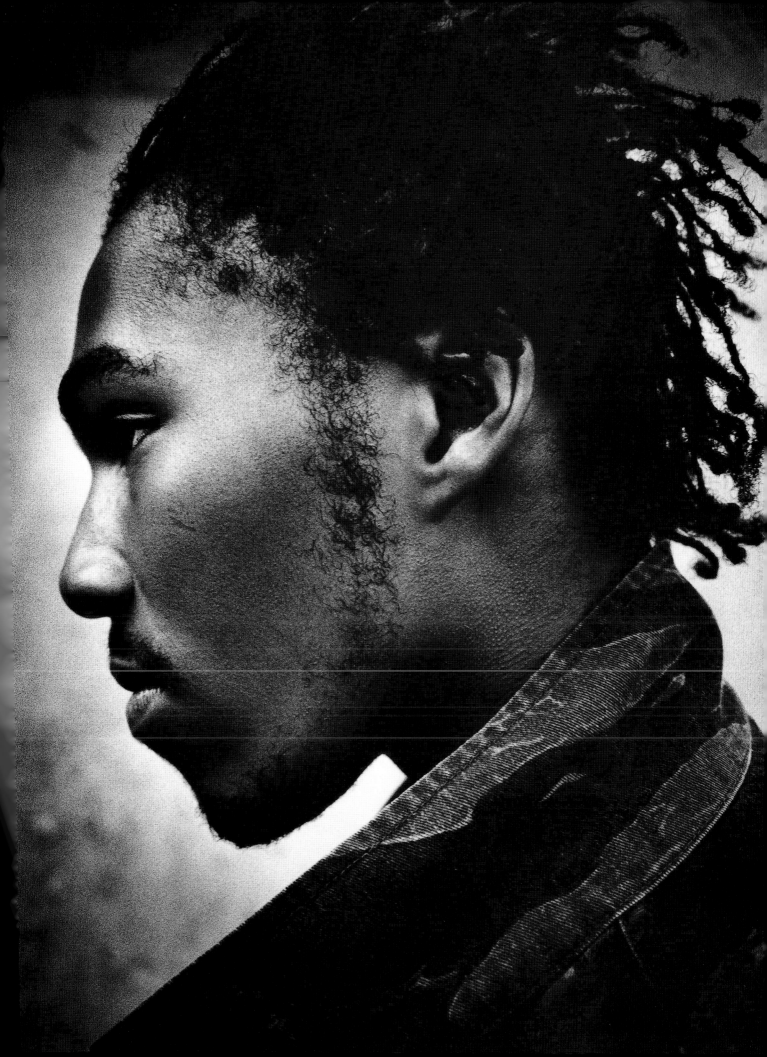

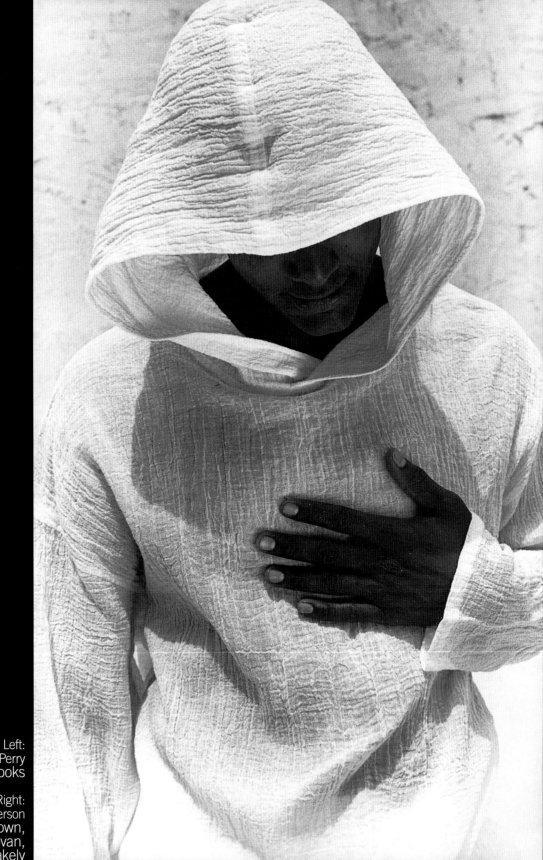

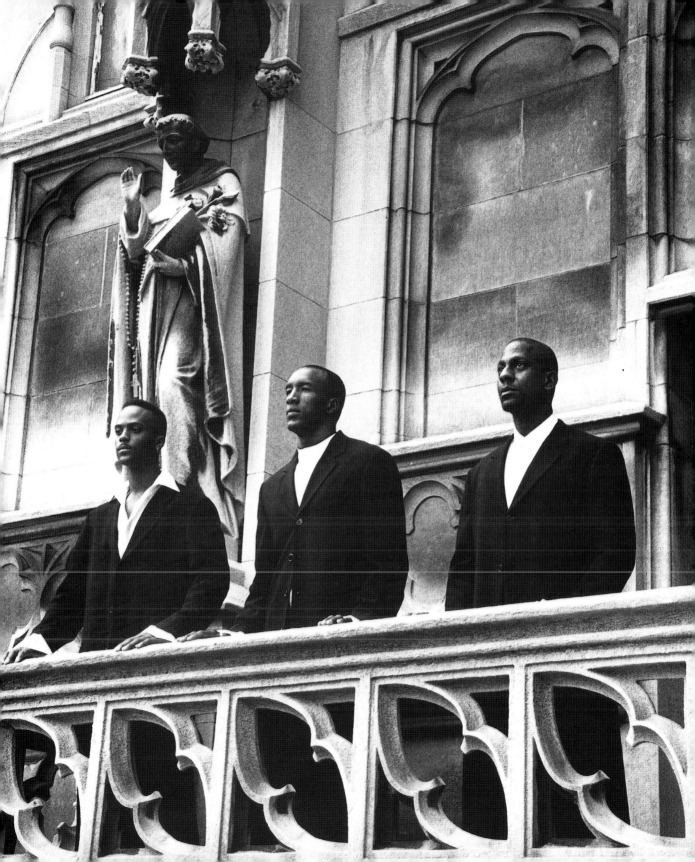

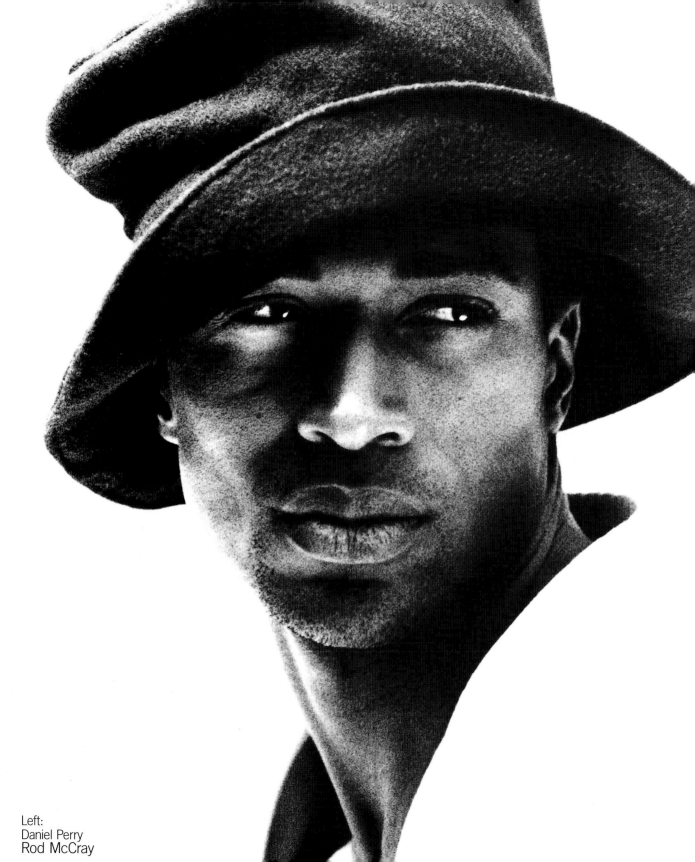

Left:
Daniel Perry
Rod McCray

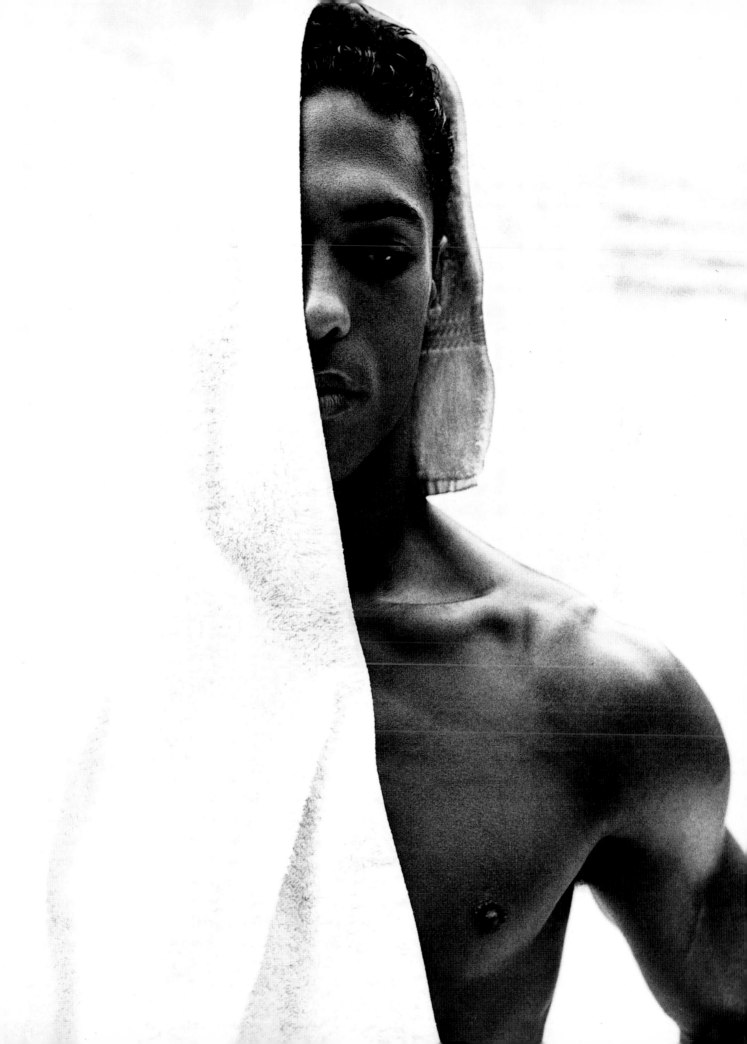

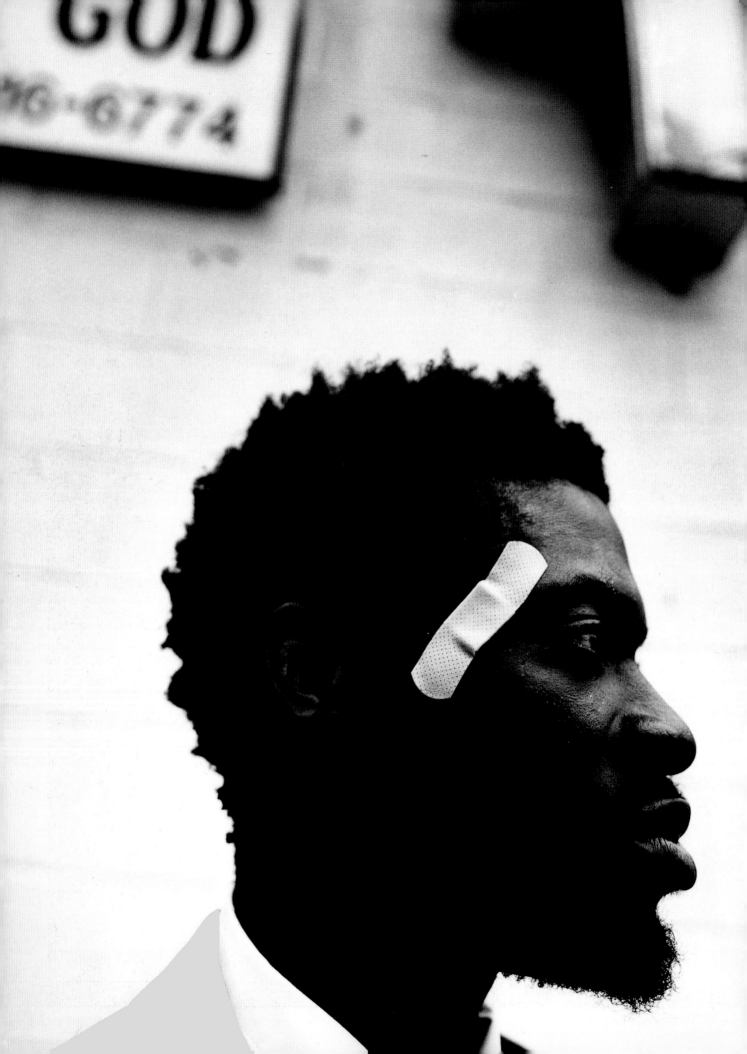

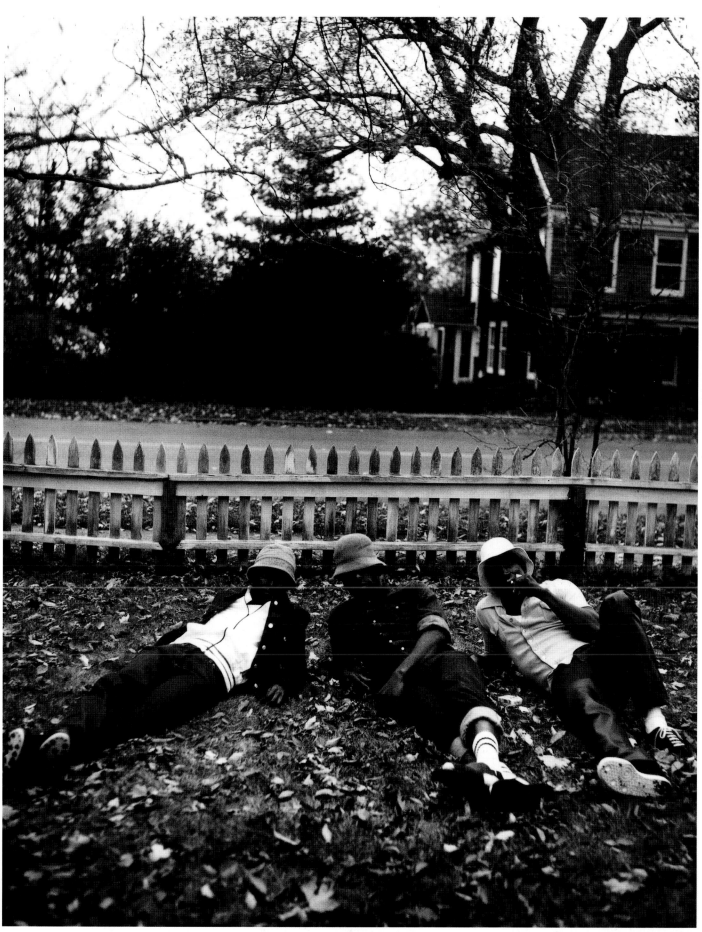

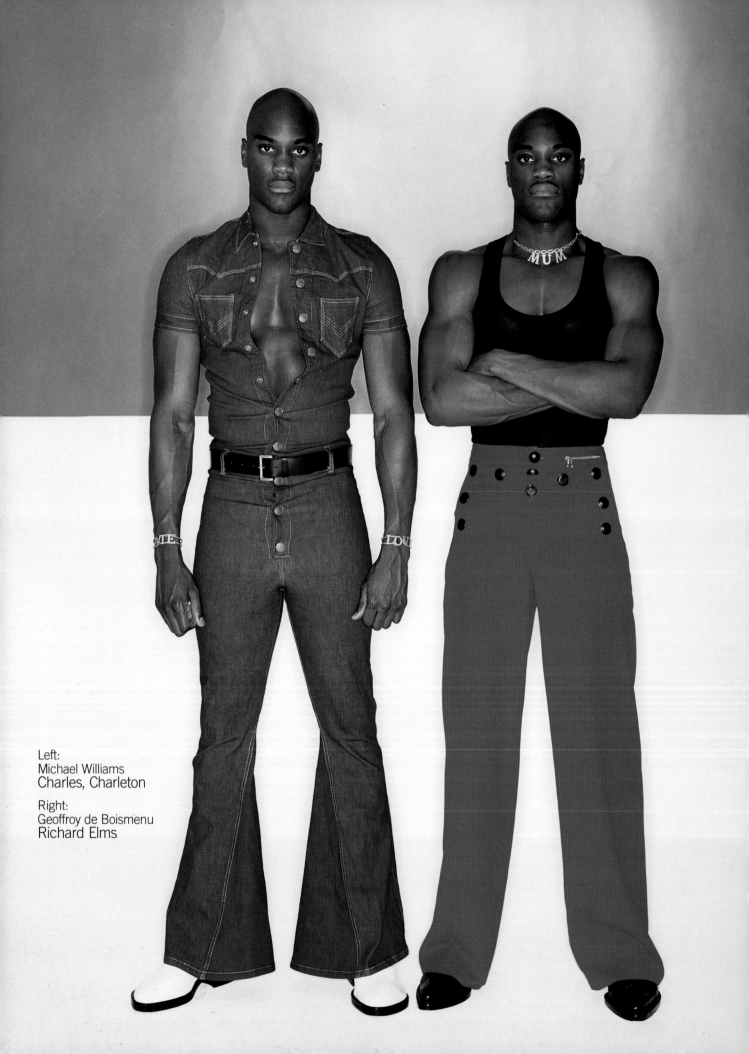

Left:
Michael Williams
Charles, Charleton

Right:
Geoffroy de Boismenu
Richard Elms

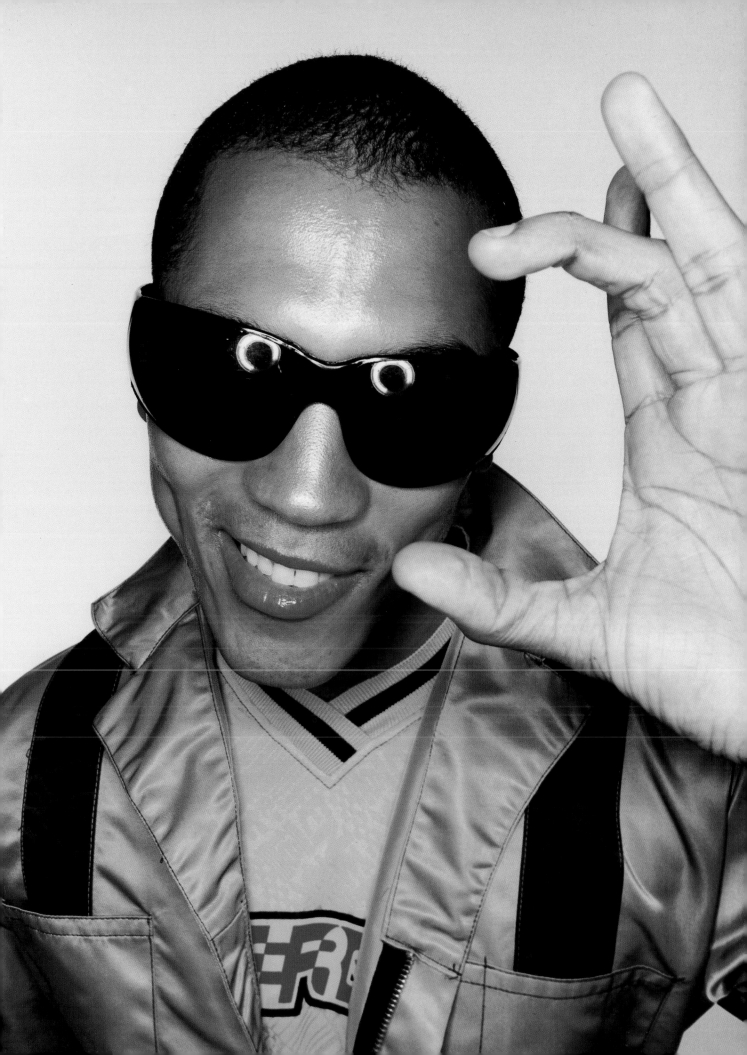

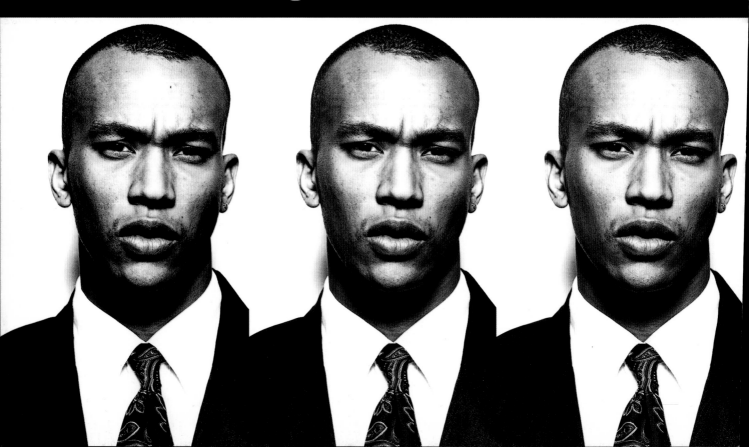

of the day, whether they were on a shoestring or champagne budget.—Mikki Taylor, *Essence*

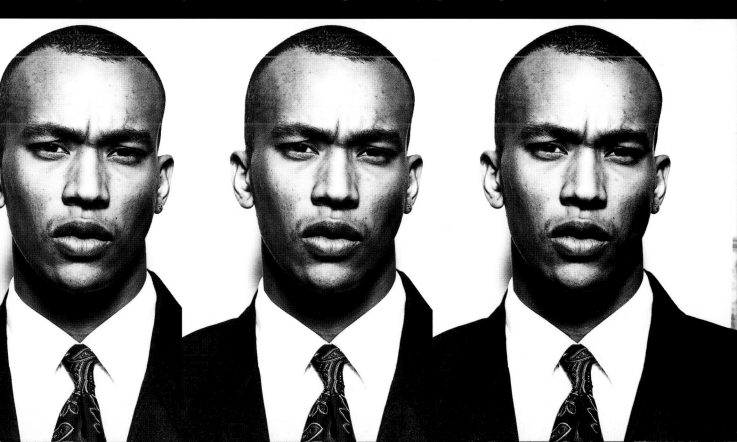

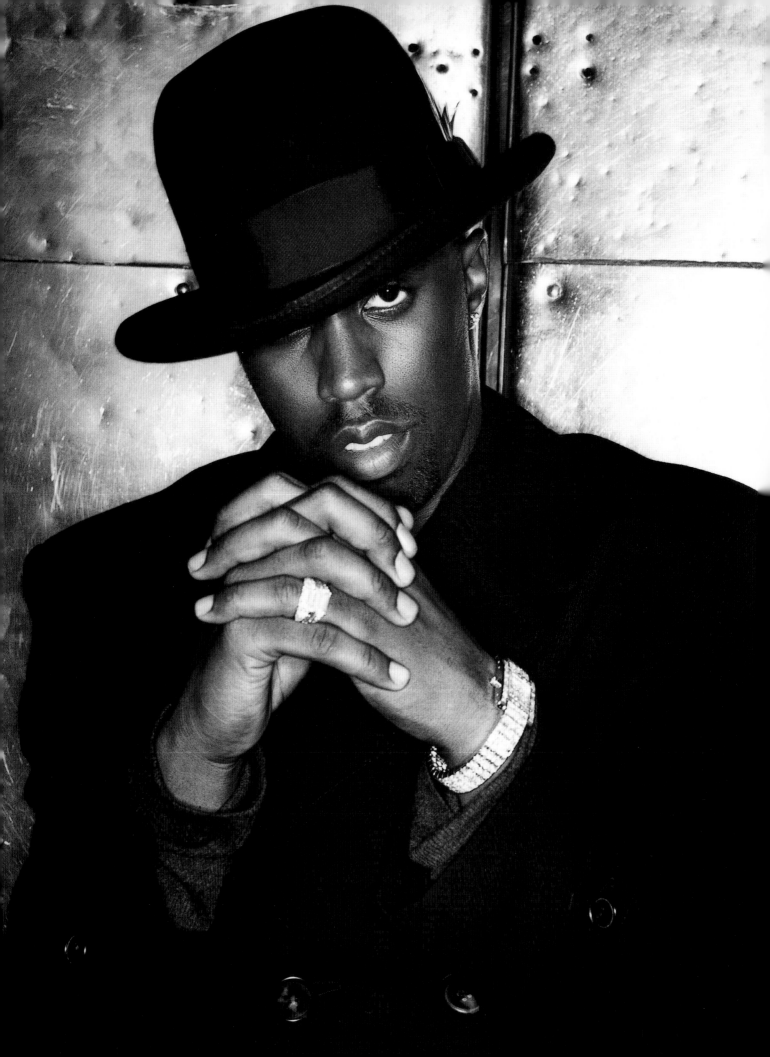

Marc Baptiste
Sean "Puffy" Combs

Black men have become much more comfortable with their image. Of course, the brothers have a few more bucks in their pocket— and it shows!
—Halle Berry, actress

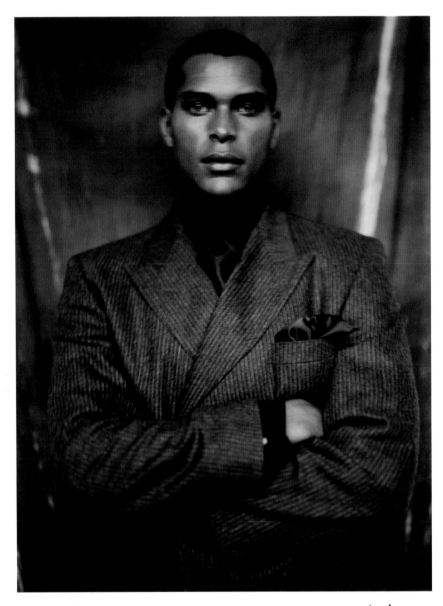

Black men have always been on a style mission. Every step is deliberate. From the head to the toes—the pinstriped pants, oxford shoes, suspenders, silk socks— they communicate a powerful aesthetic and message. —Mikki Taylor, *Essence*

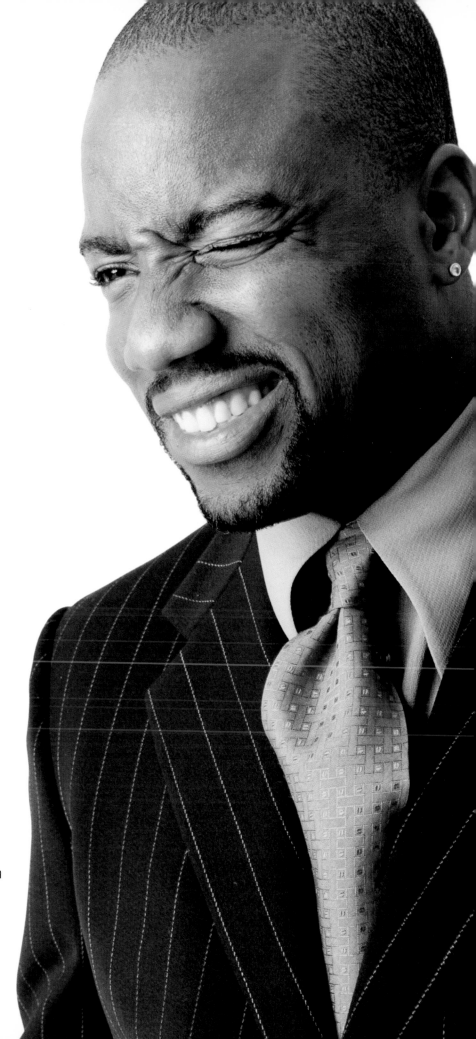

Left:
Michael Williams
Michael Anderson

Right:
Walter Chin
Malik Yoba

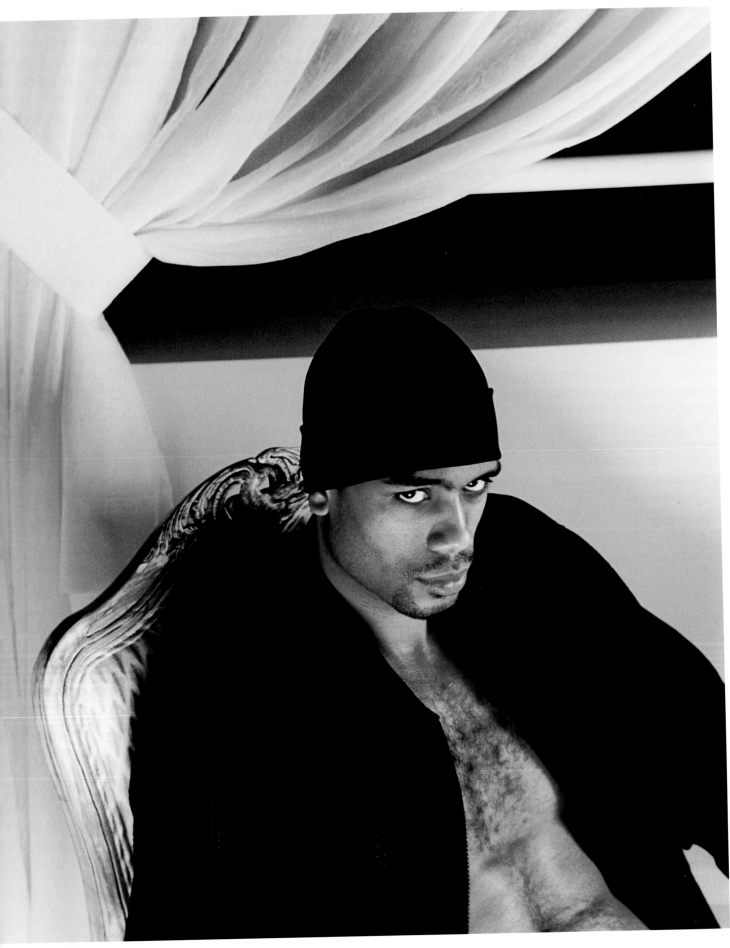

Bill Wylie
Allan Houston

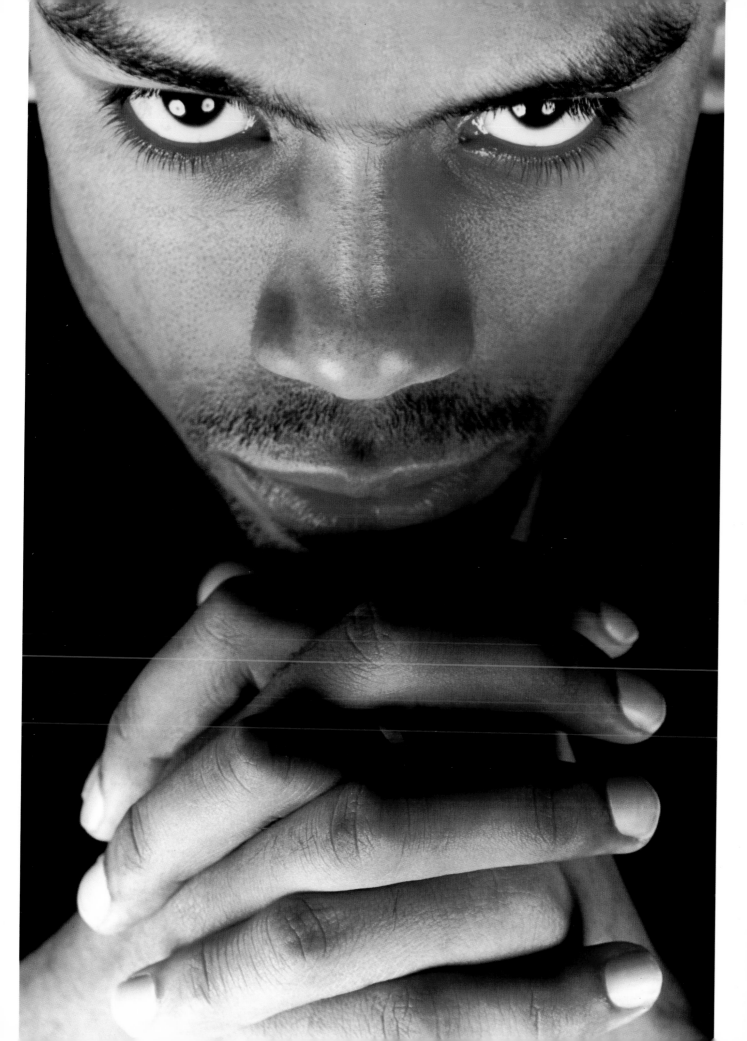

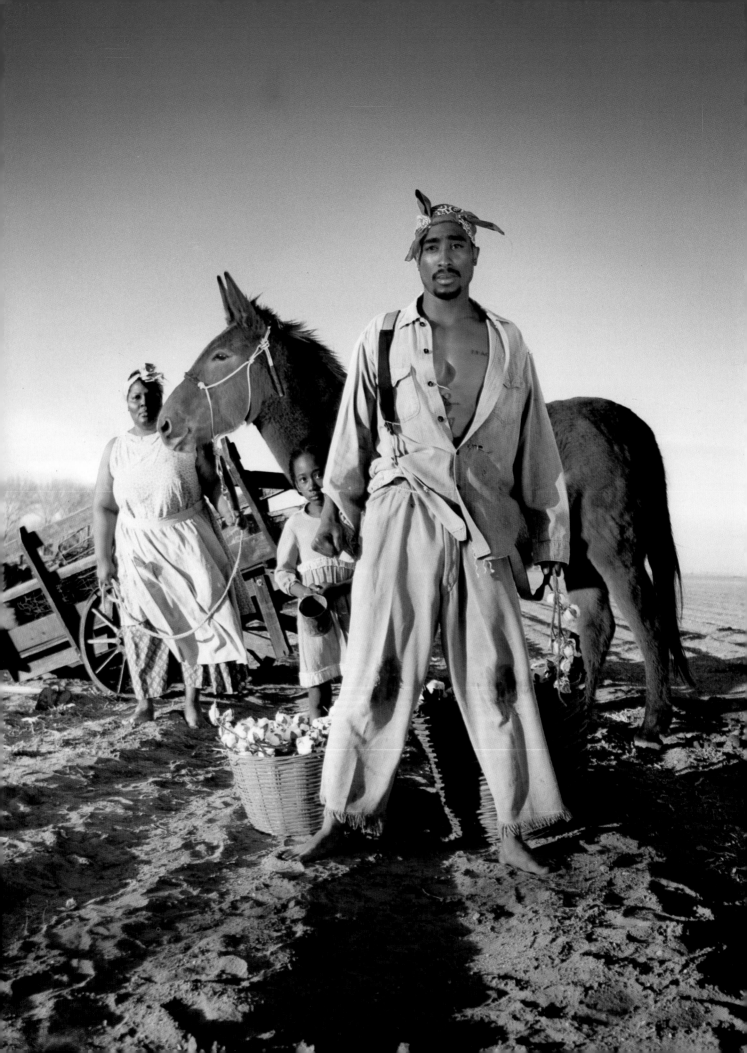

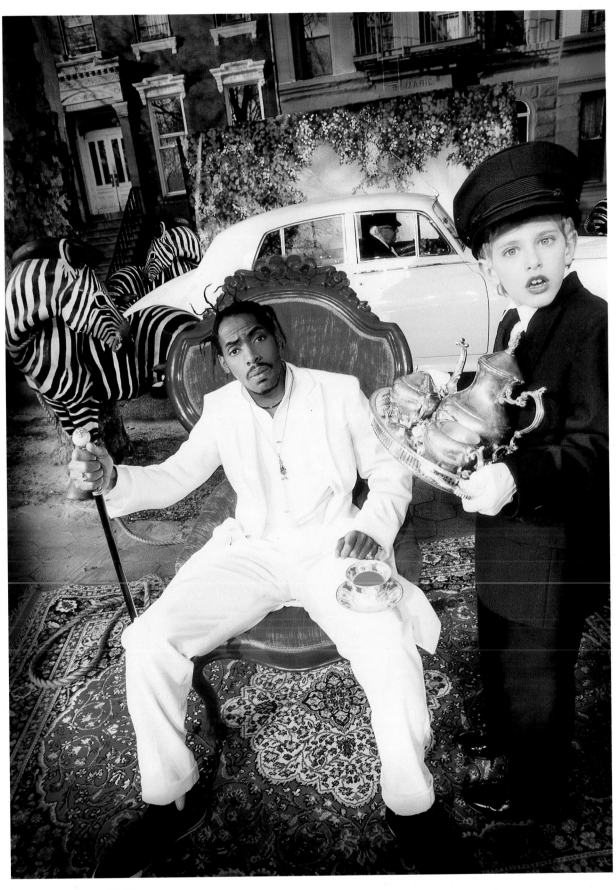

Left:
David LaChapelle
Tupac Shakur

Right:
David LaChapelle
Coolio

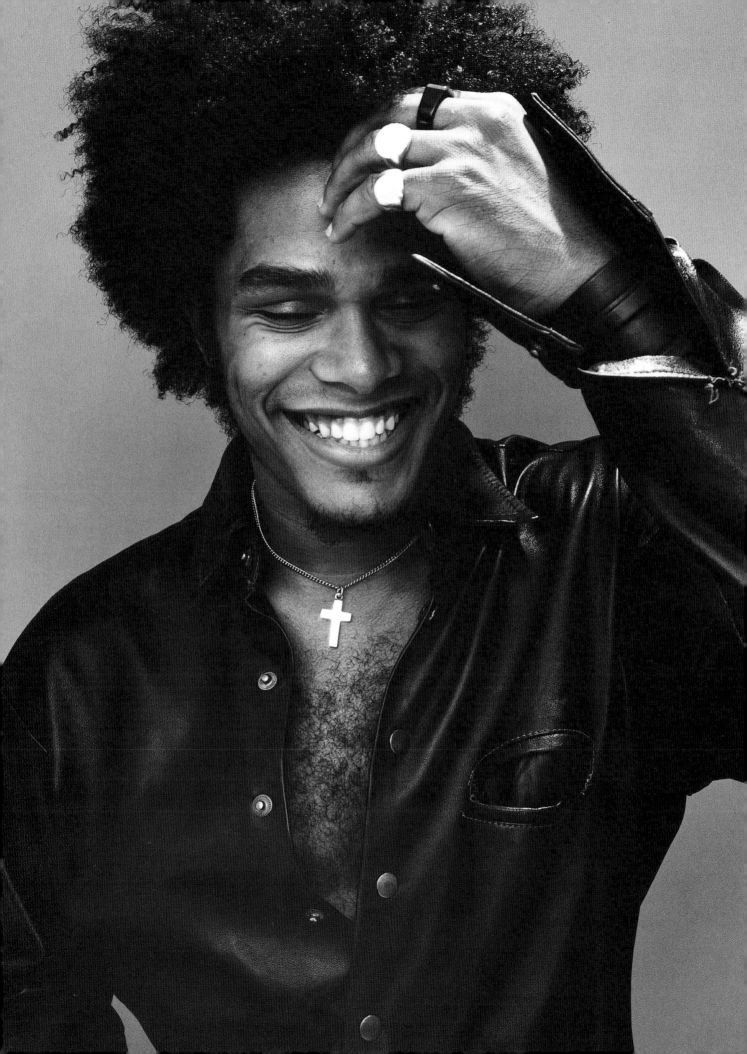

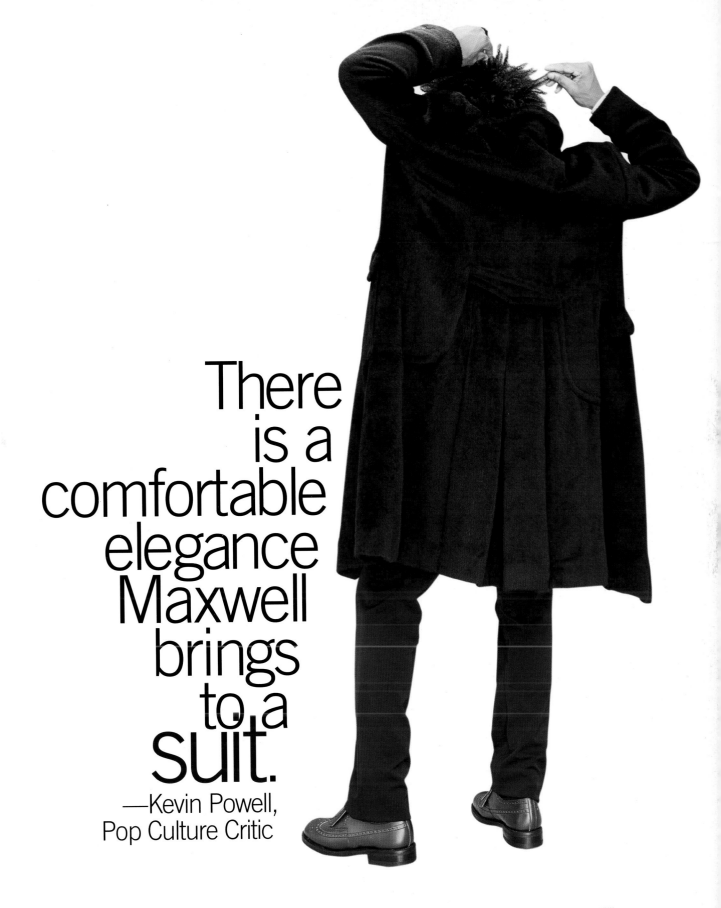

There
is a
comfortable
elegance
Maxwell
brings
to a
suit.
—Kevin Powell,
Pop Culture Critic

Michael Williams
Maxwell

Kwaku Alston
Wyclef Jean

Long before Frank Sinatra,
there were black men in the
Caribbean with the natty
little hats tipped to the side.
—Mikki Taylor, *Essence*

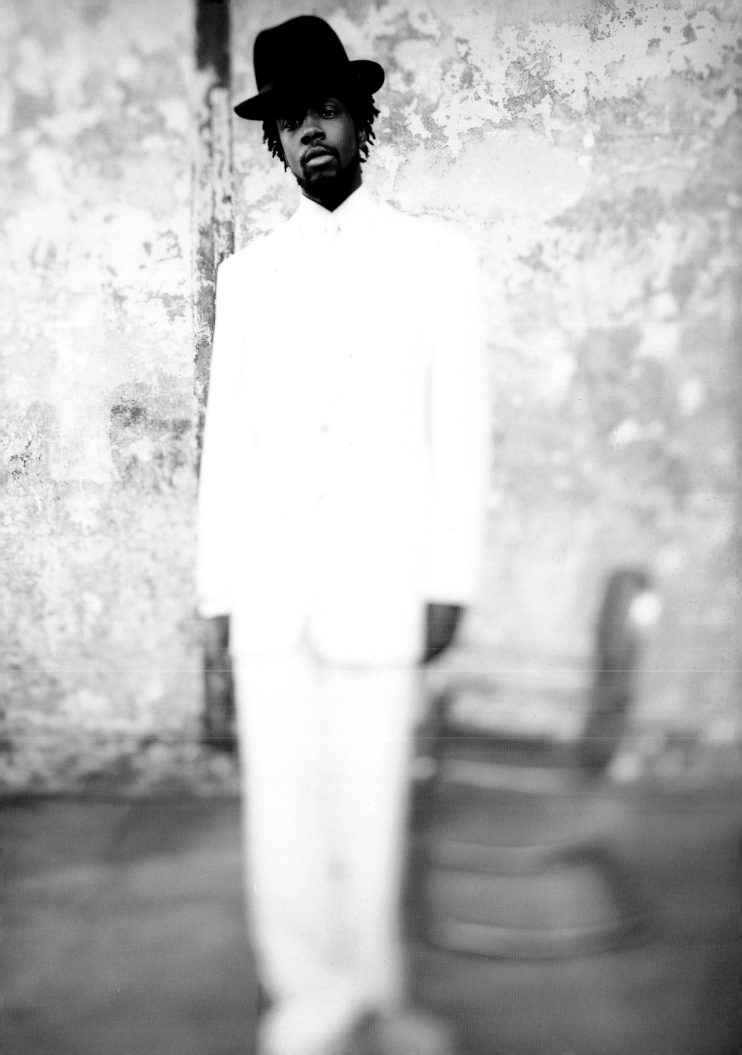

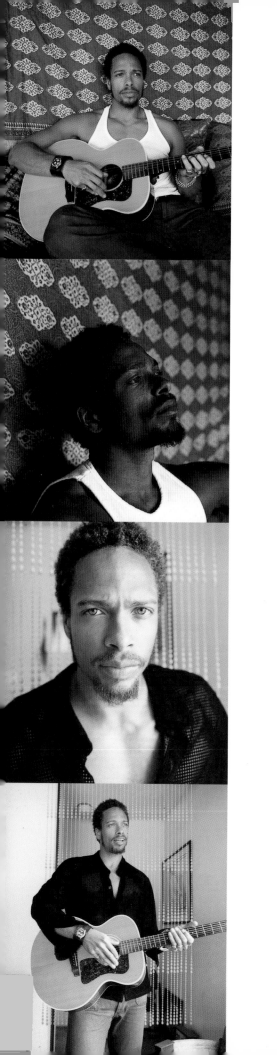

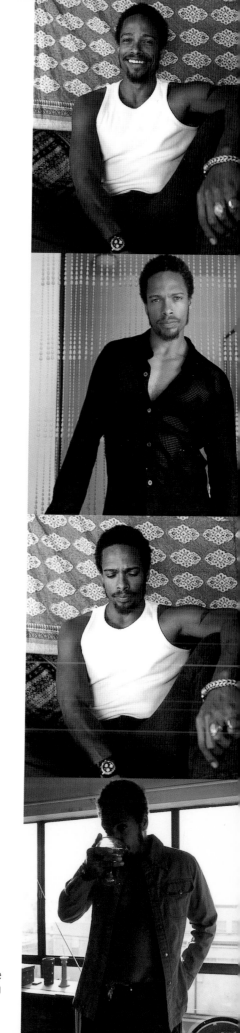

Marc Baptiste
Gary Dourdan

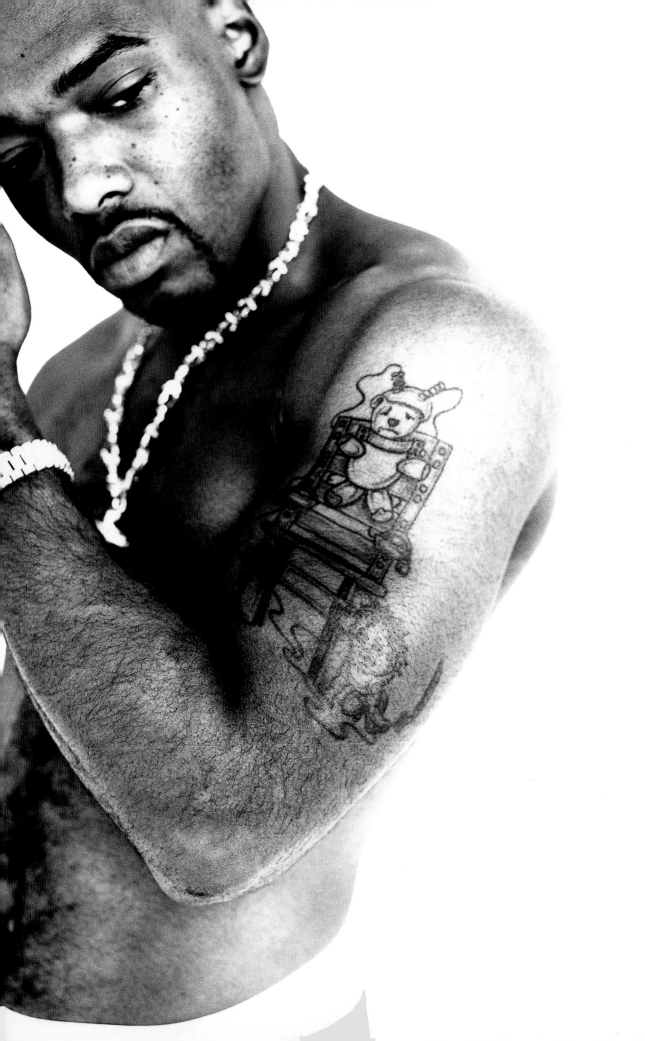

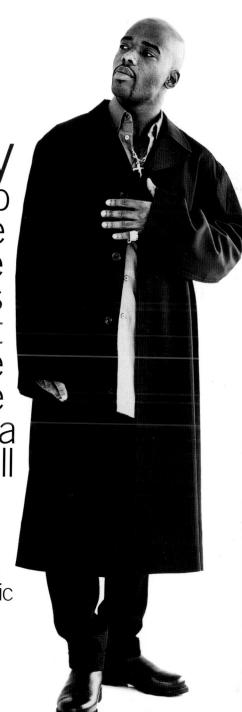

There is a duality going on in hip-hop fashion. On one hand, there are the Hugo Boss suits with elegant Kenneth Cole shoes. On the other, it's about a hoodie, baseball cap, baggy pants, the "Michelin" coat, and Timberlands.
—Kevin Powell, Pop Culture Critic

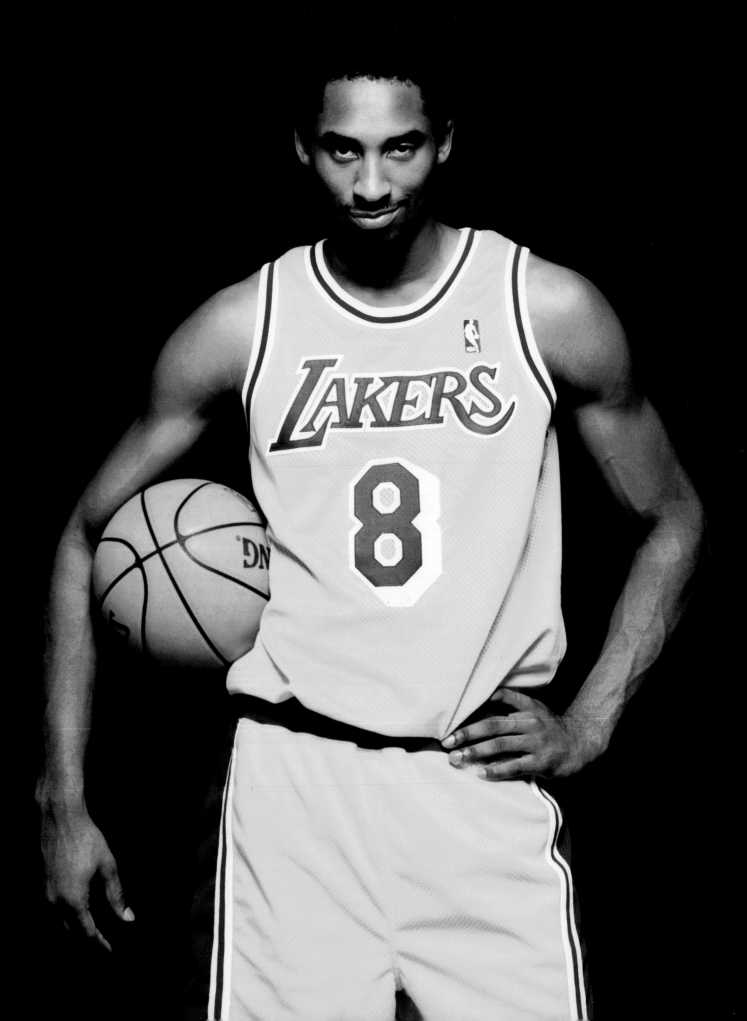

Left:
Piotr Sikora
Kobe Bryant

Right:
Piotr Sikora
Rakim

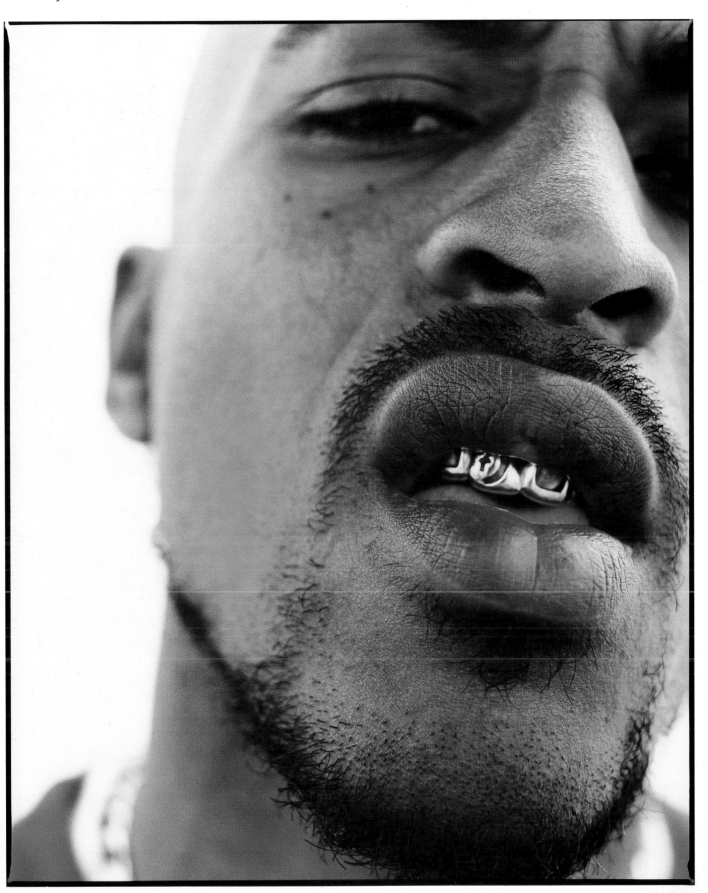

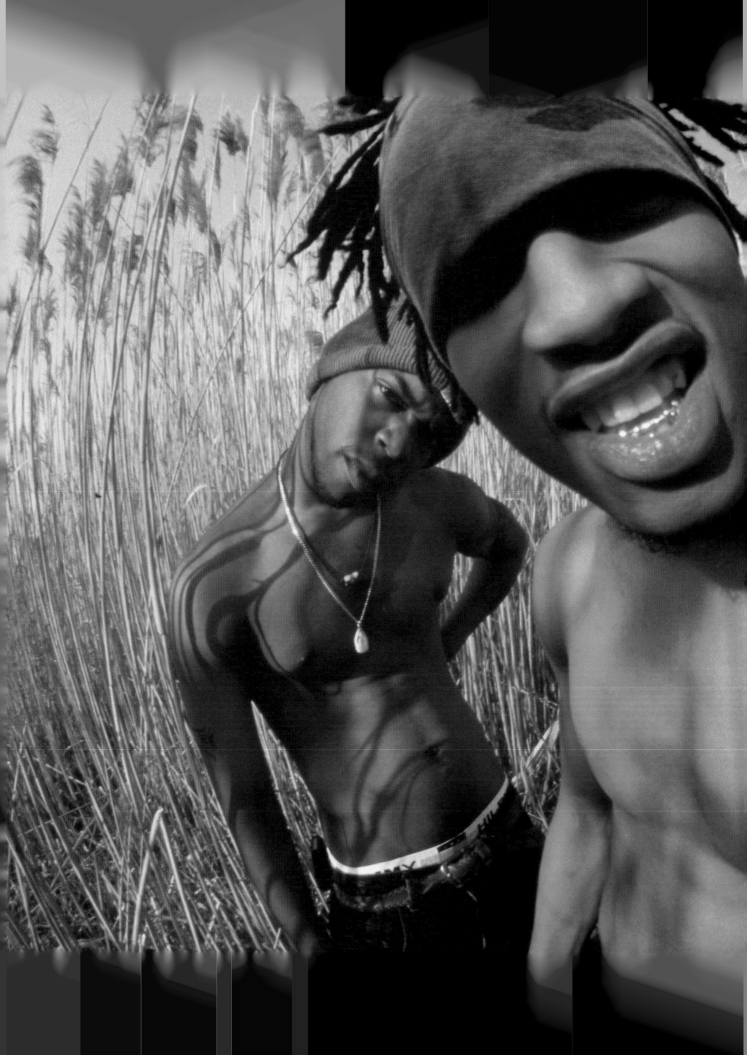

The heavy hitters
of the fashion industry
have all taken cues
from street-savvy
black youth.
—Richard Reid, writer

Piotr Sikora
Smif N Wessun

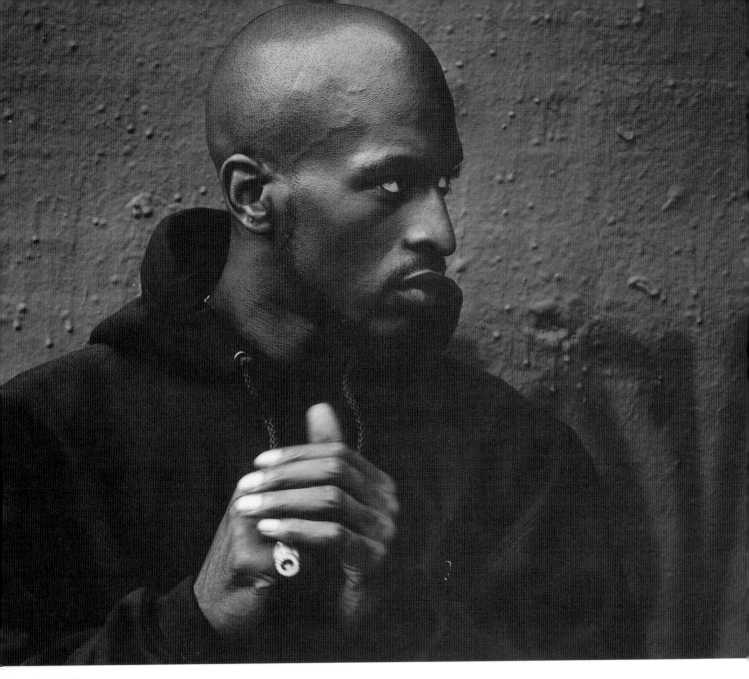

Piotr Sikora
Rakim

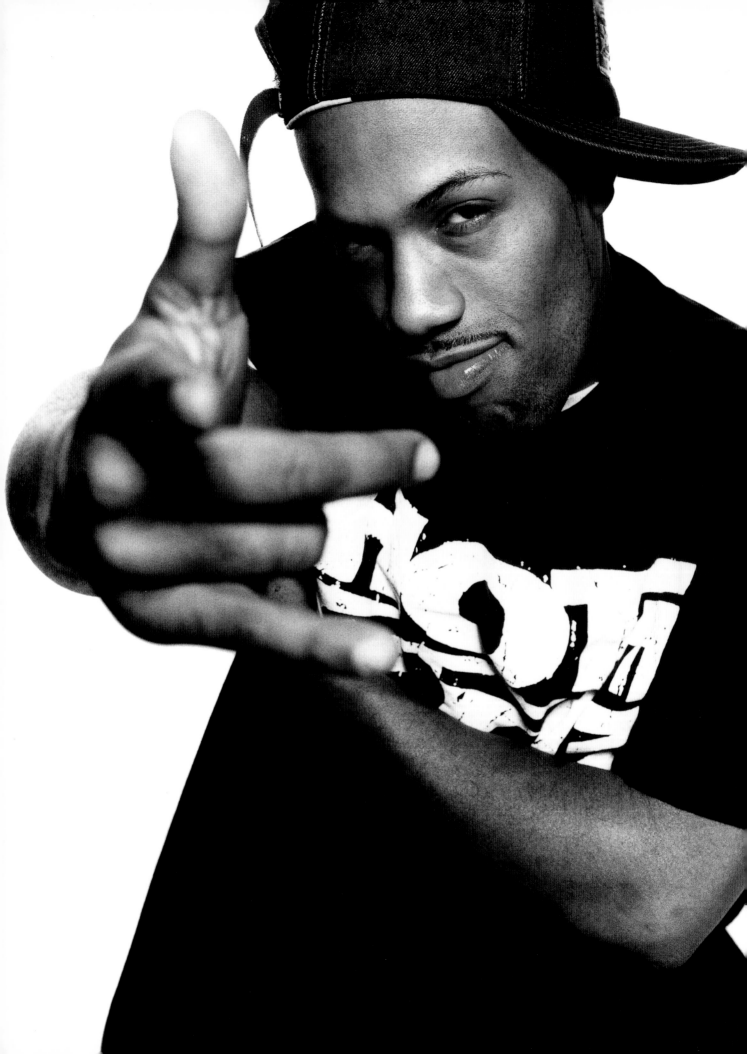

Piotr Sikora
Redman

# Hip-hop
has become
more than a
musical sound.
It is a complete
package of
cultural ideology
that includes,
perhaps as its
most
recognizable
trait, style.
—Richard Reid, writer

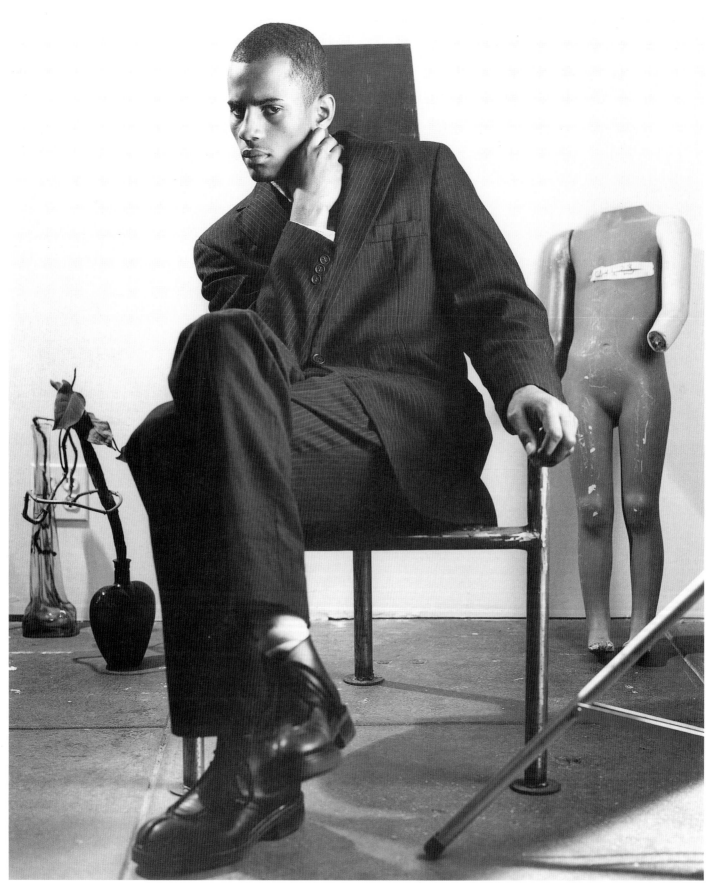

Michael Kenneth Lopez
Ghurron

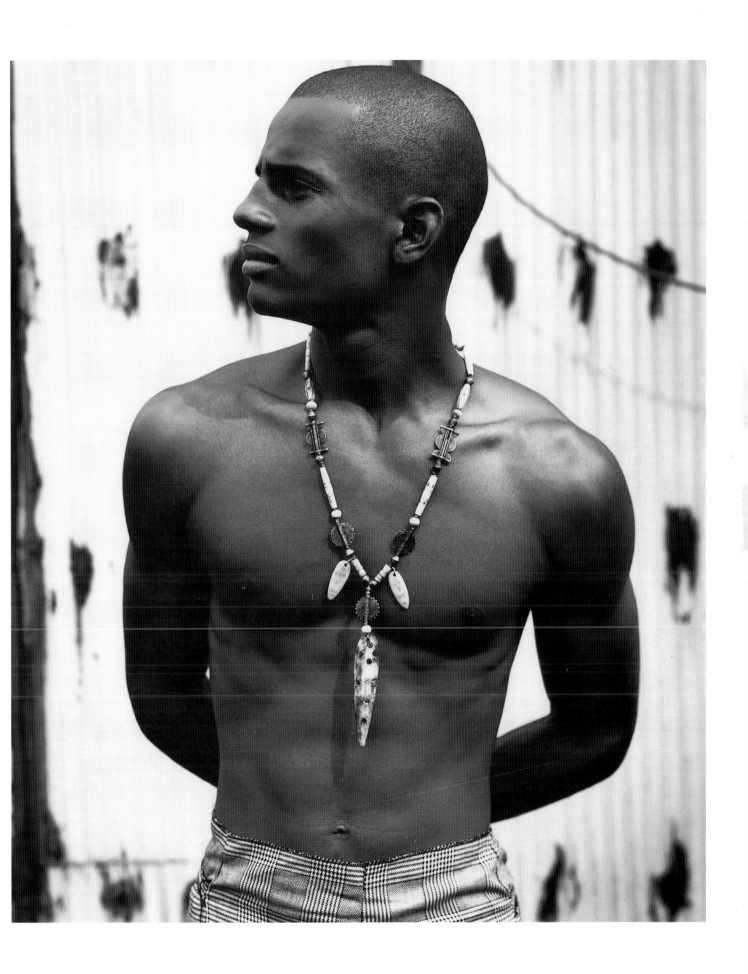

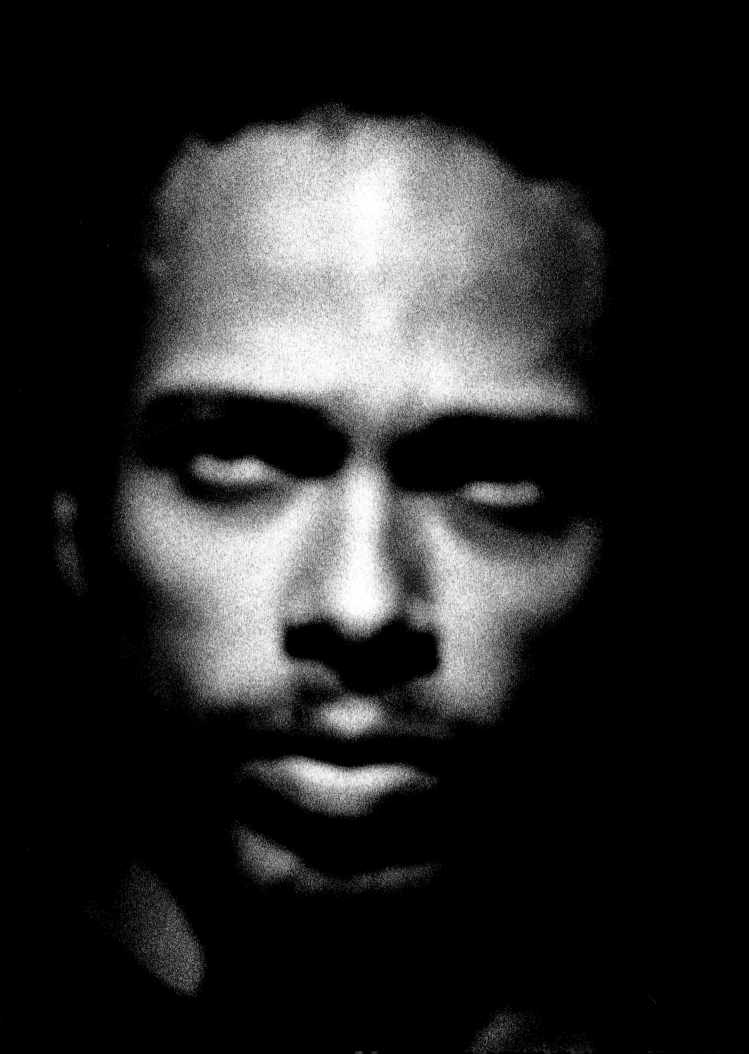

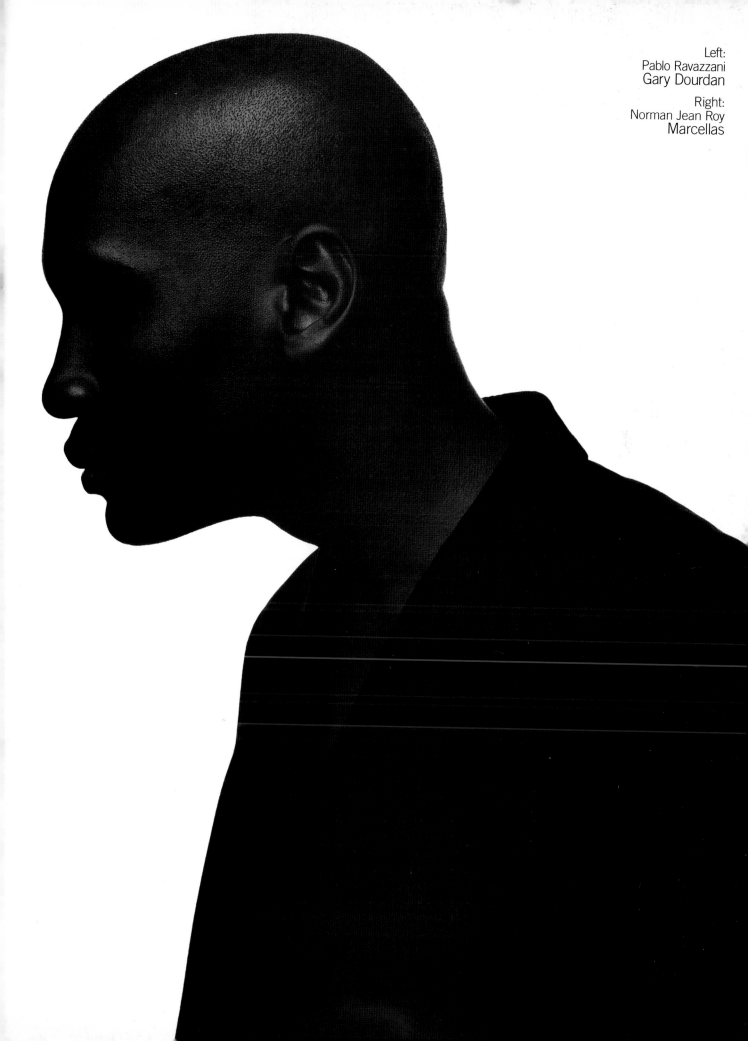

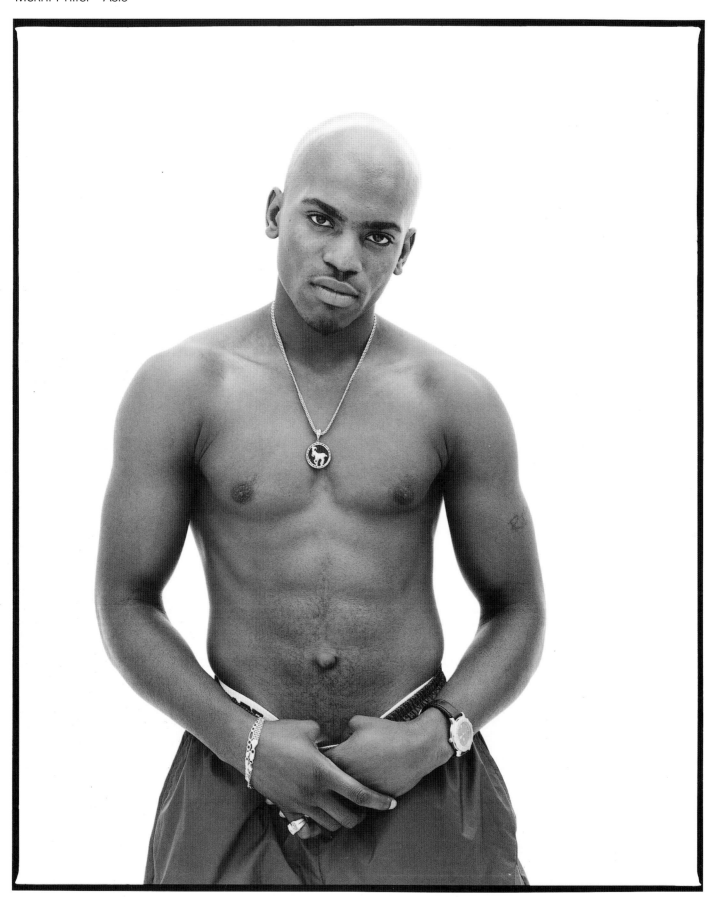

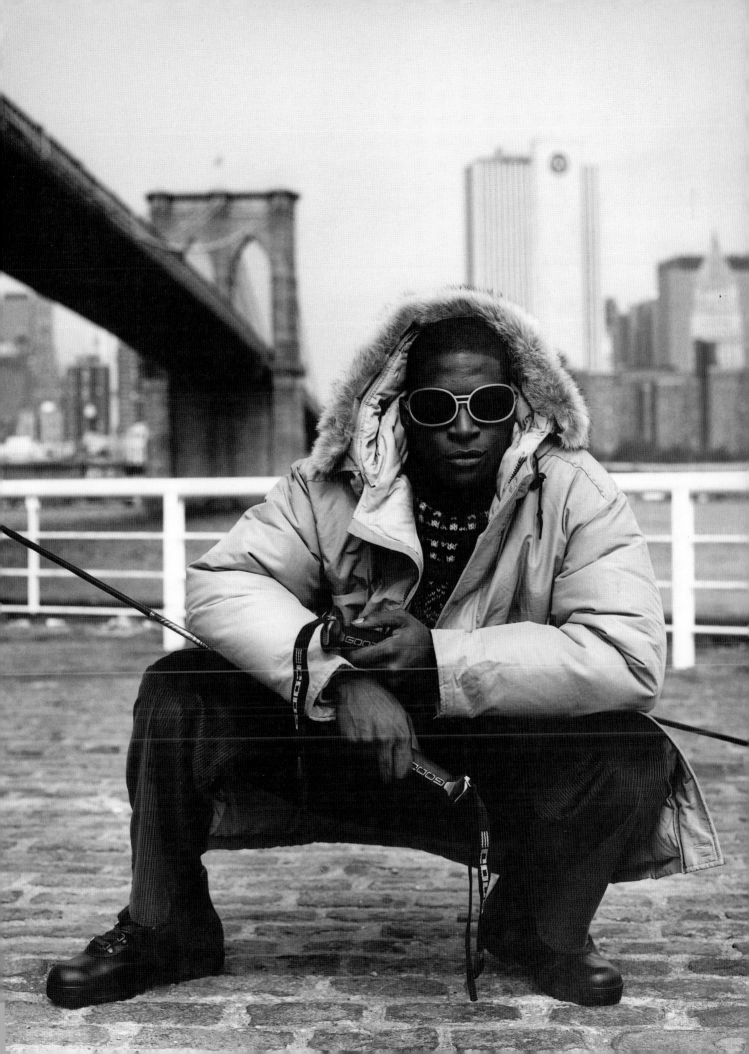

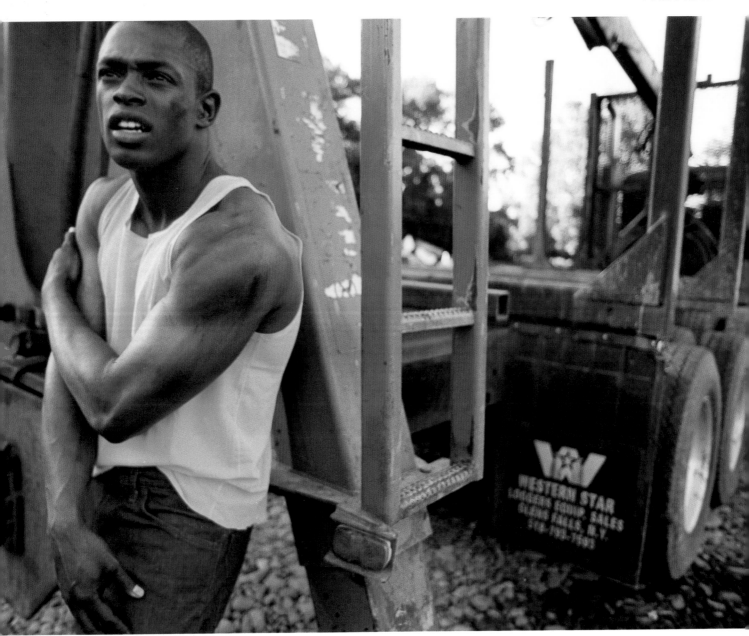

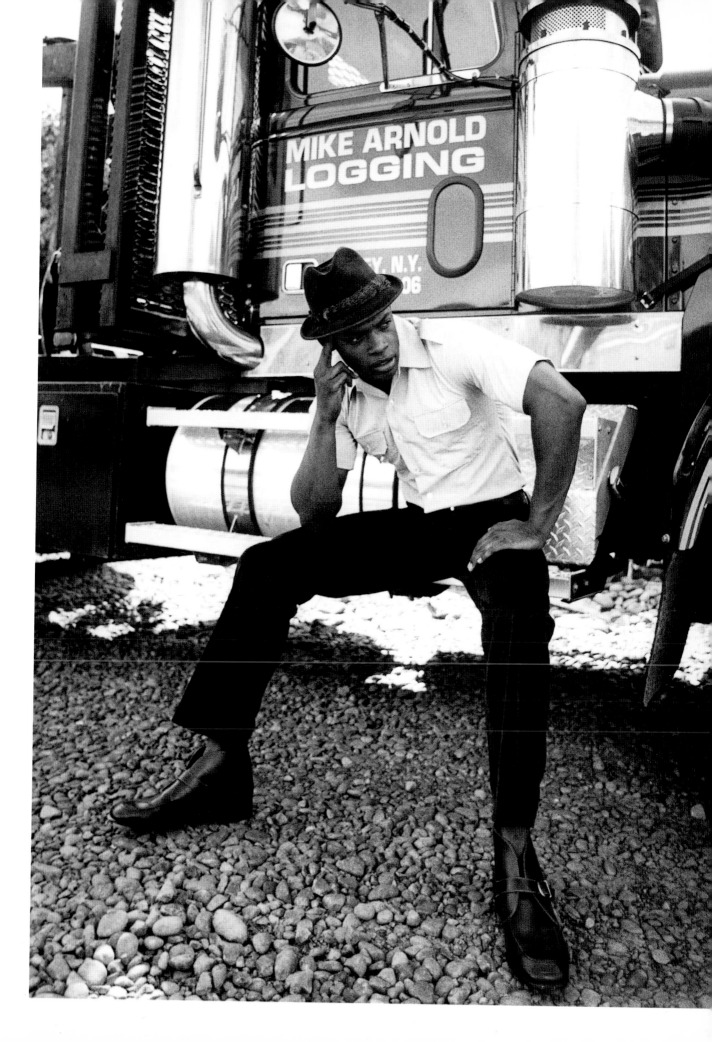

Left:
David LaChapelle
Tricky

Right:
Jesse Frohman
Chris Rock

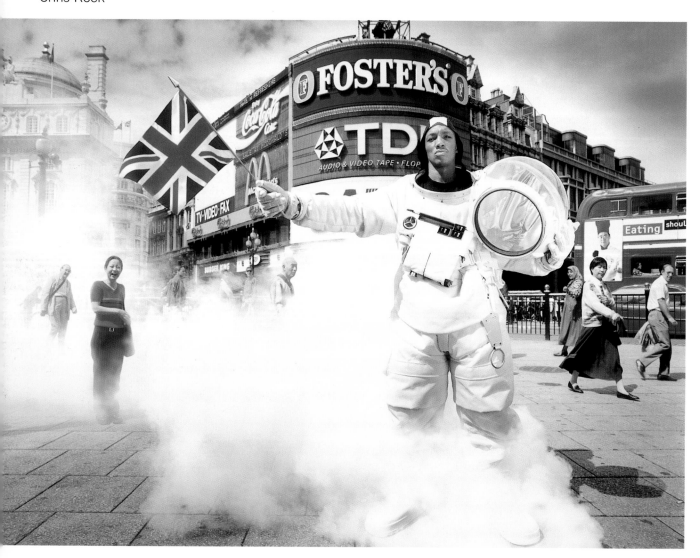

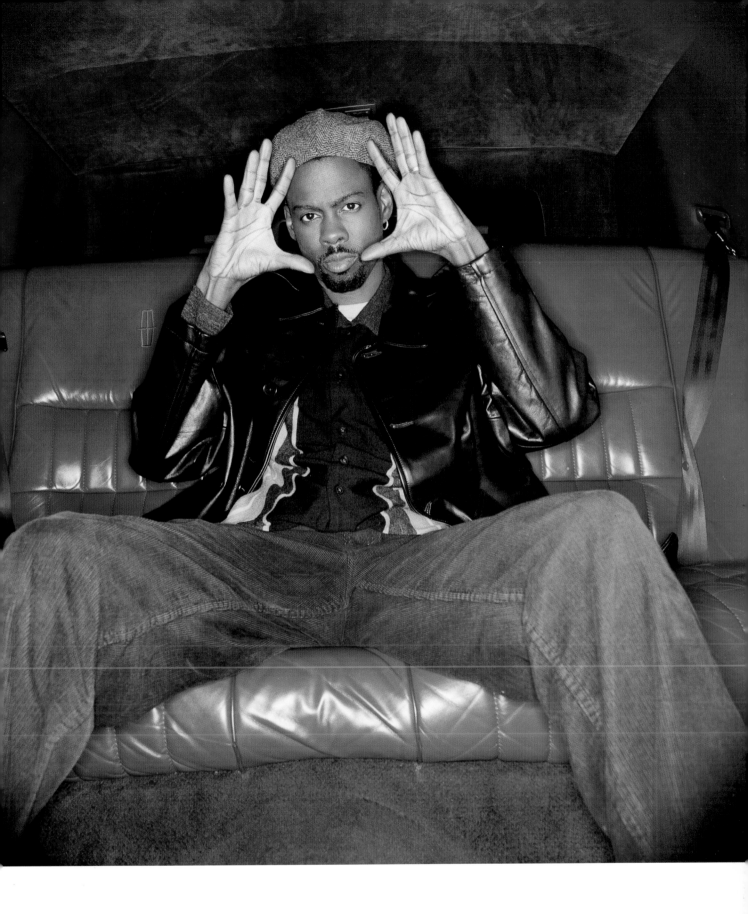

# Index

Djimon is the epitome of what a strong black man should be. He posseses dignity and great compassion.
—Renee Sheffey-Brown, *Essence*

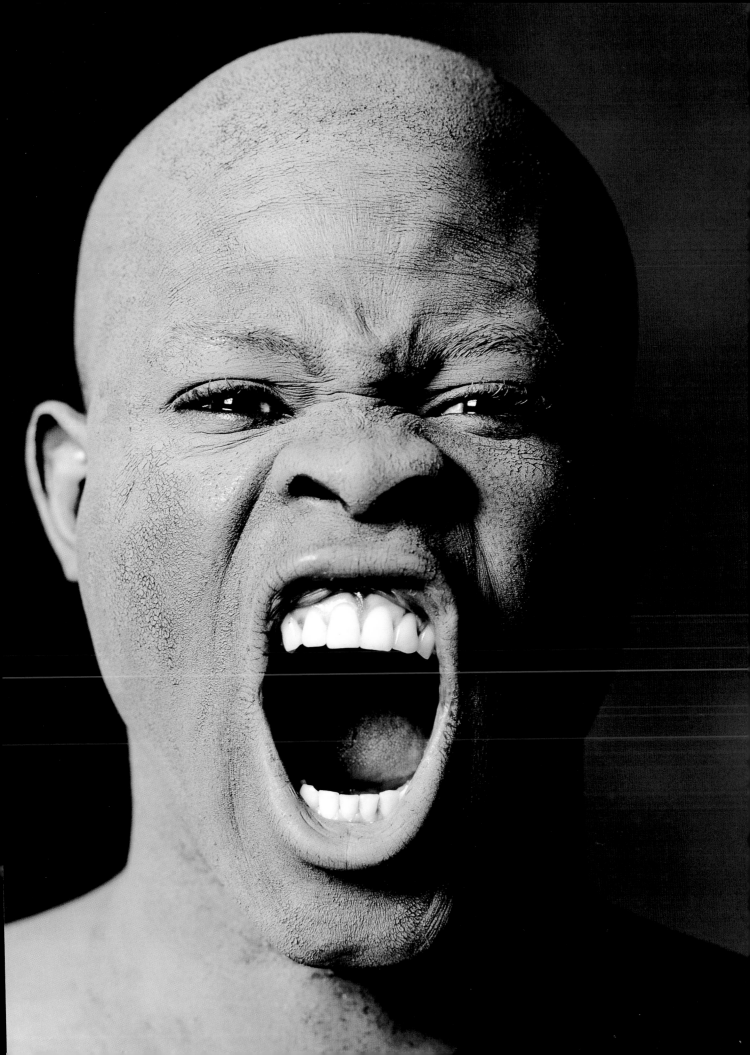

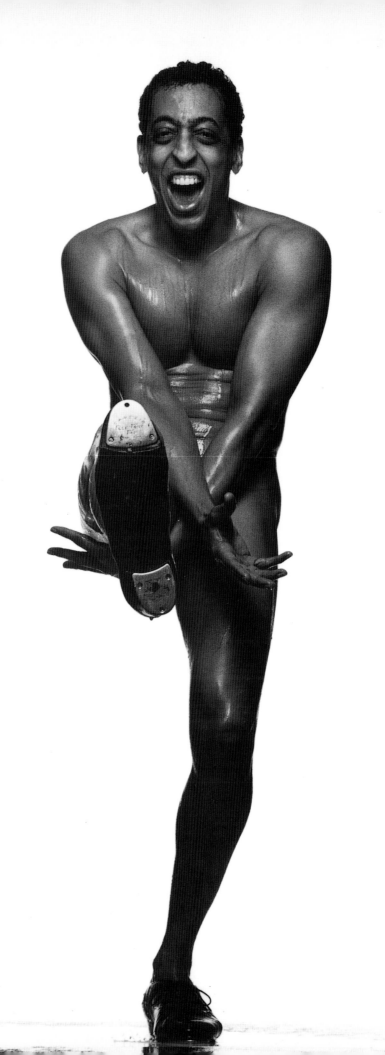

Michel Comte
Gregory Hines

# Photographers

Kwaku Alston
Marc Baptiste
Ripp Bowman
Walter Chin
Michel Comte
Rick Day
Geoffroy de Boismenu
Patrick de Warren
Bob Frame
Jesse Frohman
Greg Gorman
Eric Johnson
David LaChapelle
Thierry Le Gouès
Michael Kenneth Lopez
Jonathan Mannion
Philippe McClelland
Melodie McDaniel
Daniel Perry
Charlie Pizzarello
Platon
Pablo Ravazzani
Norman Jean Roy
Piotr Sikora
Michael Stratton
Ben Watts
Edward Wilkerson
Michael Williams
Bill Wylie

Part of the proceeds from the sale of this book will benefit the Minority Task Force on AIDS.

Editor  DAVID McANINCH
Creative Editor  JULIUS POOLE
Associate Editor  RICHARD REID
Contributing Writer  DEBORAH GREGORY
Creative Consultant  RICHARD HEARNS

## Biography

Duane Thomas is a partner in a design studio specializing in creating advertising for fashion and beauty companies. He is a contributing magazine art director who has worked for *Vogue, Elle, Essence, In Style, Details,* and *Esquire.* He is also founder and art director of *Noir,* a New York–based style magazine for African-Americans.

## Colophon

Layouts for this book were set and generated in Quark XPress 4.0 using an Apple Power Macintosh 6500/225, a Hitachi RasterOps 21-inch color monitor and an Epson Stylus 1520 color printer. The type was set in Trade Gothic Light.

## Acknowledgments

Thank you Charles Miers, David McAninch, and James Stave at Universe Publishing for seeing the beauty in black men.

Thank you Veronica Webb for your excellent introduction. You took the words right out of my mouth!

Many thanks to all the photographers, subjects, and their agents without whom this book would not have been possible.

Thank you Marc Baptiste, Julius Poole, Richard Reid, Deborah Gregory, and Richard Hearns for your hard work.

Thank you Jennifer Thomas, Joanne Wu, John Moore, Lynda Jones, Victor Gonzalez, Cherlyn Miller Grier, David Doty, Jenny Baptiste, Dawn Hewitt, Robin Jones, and Cheryl Ann Wadlington for your suggestions, support and encouragement.

Many thanks to all the editors, stylists, and groomers who produced these images.

Thank you The Edge and Color Edge for your generosity and brilliant prints.

Thank you Christopher J. Bishop for your generosity and great work retouching prints.

Thank you Mom and Dad for years of support and encouragement.

Right:
Marc Baptiste
Charles

Following page:
Pablo Ravazzani
Jason Olive

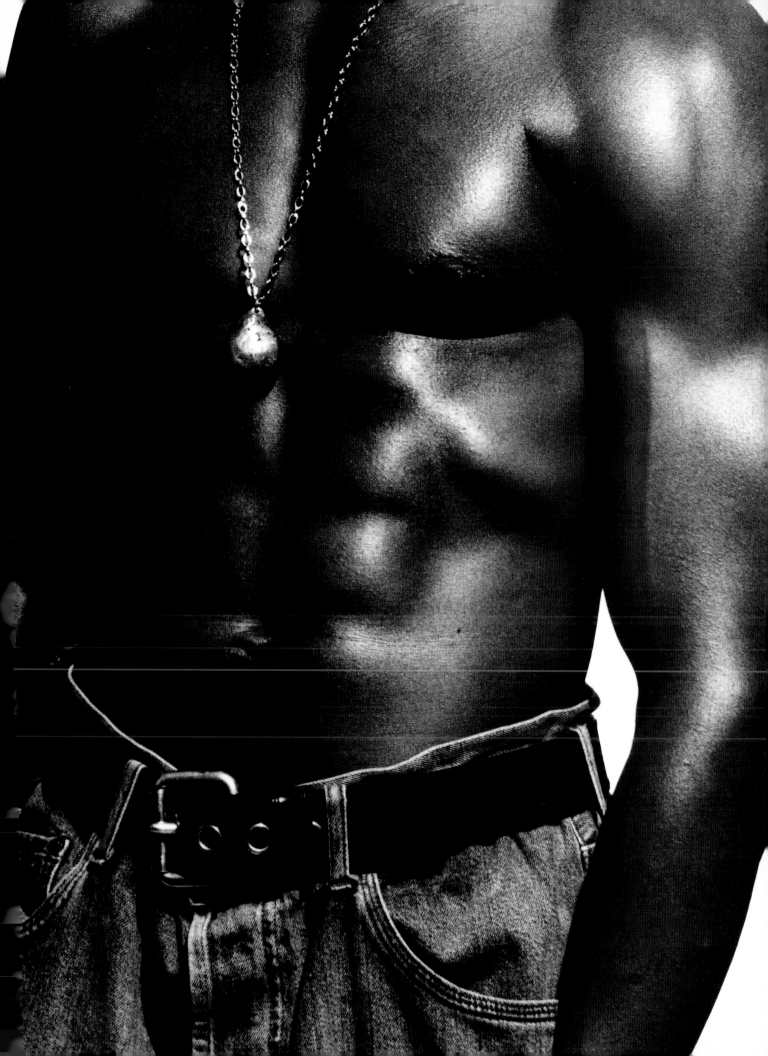

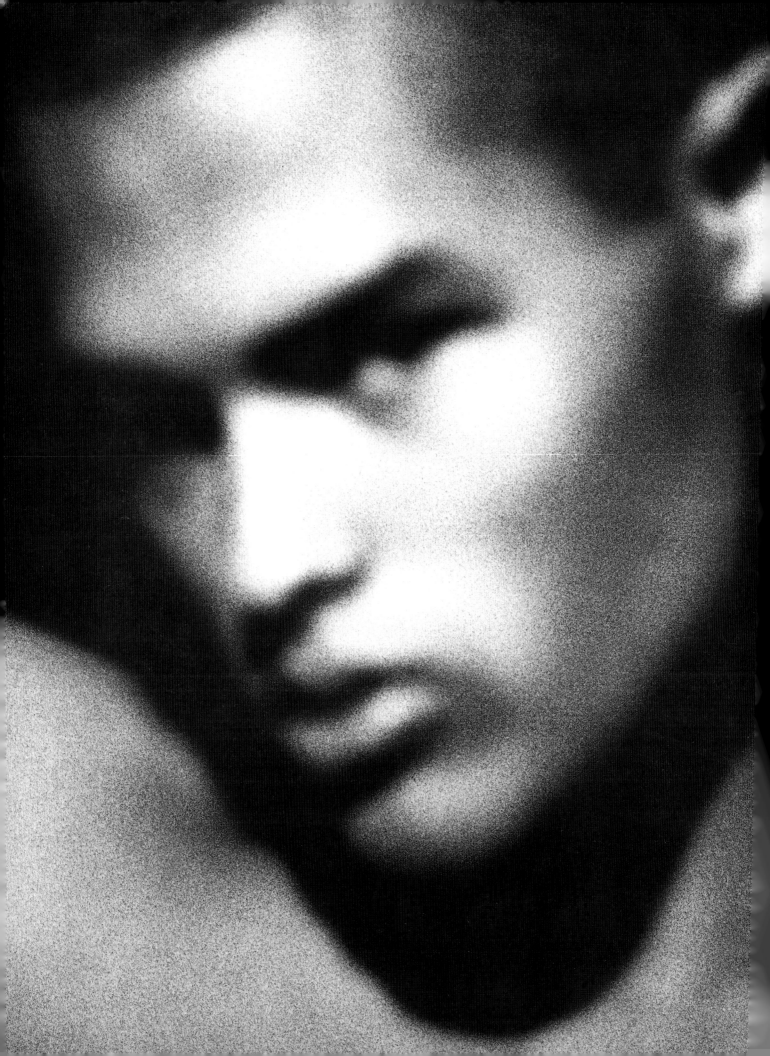